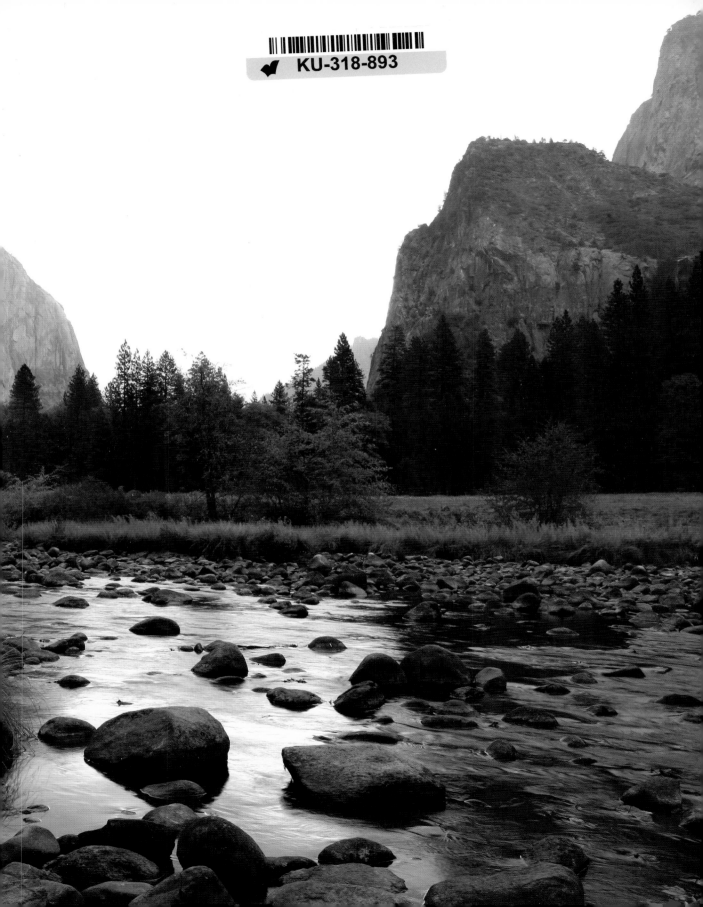
KU-318-893

CALIFORNIA

teNeues

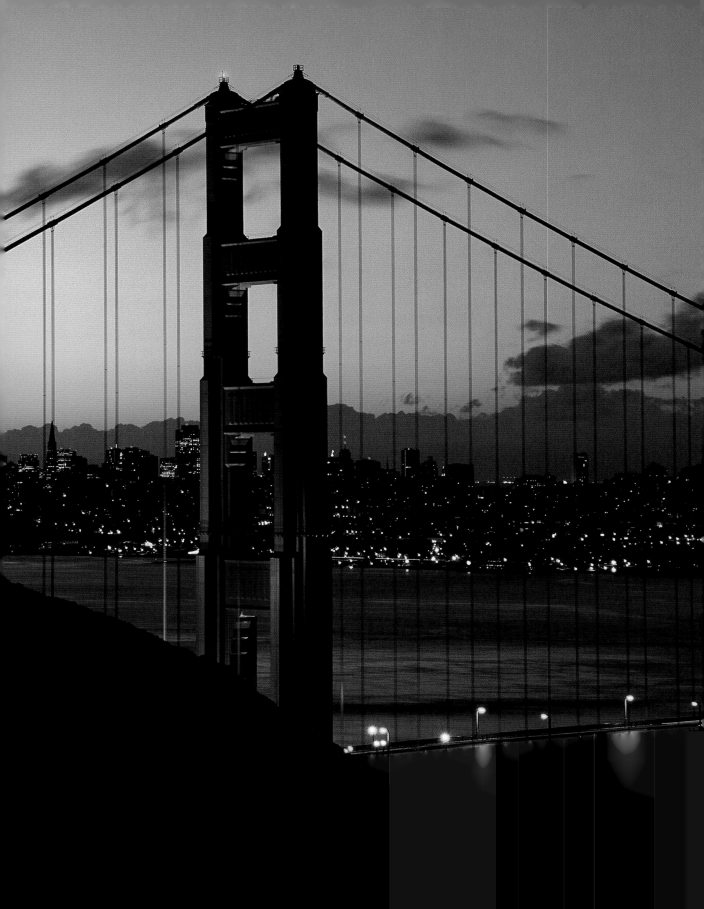

CALIFORNIA

Photographs by Christopher Bliss
Text by Jean Stern

teNeues

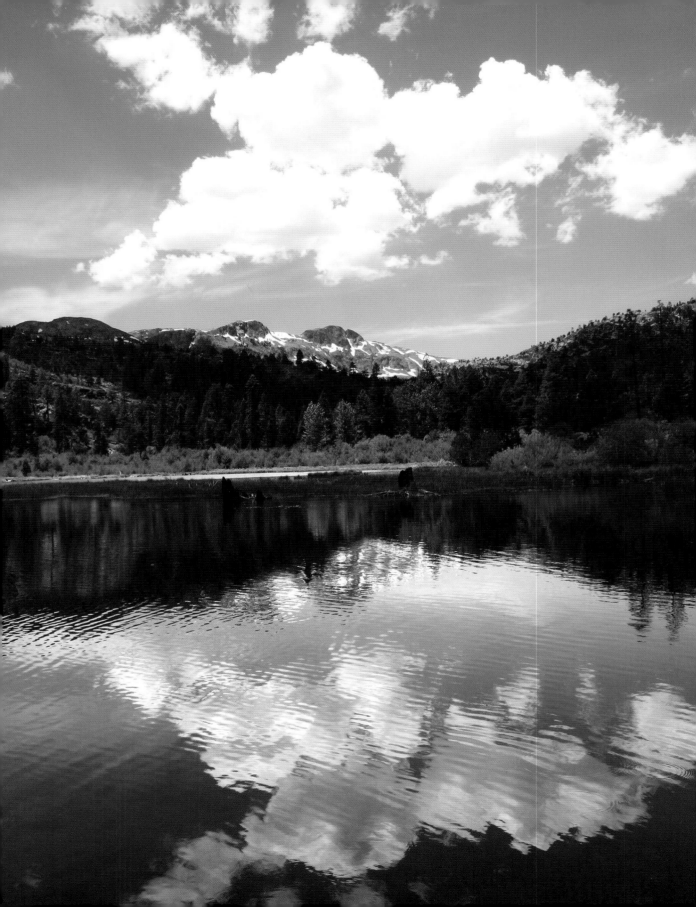

California denotes much more than a place—it implies a lifestyle, a space for ingenious, artistic, and enterprising leaders of society to live and play. Throughout the world, California is known as the place where wondrous things are invented and developed. It is the wondrous garden where everything grows and the magical place where movies are made.

Historically, California's unlimited opportunities attracted countless newcomers, reaching back as far as the Native Americans. Others followed: the Conquistadors of the 1500s as well as the padres of the eighteenth and early nineteenth centuries, who built the 21 missions that stretch from San Diego to just north of San Francisco. In 1849, fortune seekers flocked to the Sierras for the Gold Rush, and the years after World War II saw the beginning of another population boom. So dynamic is life in the most populated of the fifty United States that, if it were an independent nation, California could boast the eighth largest economy in the world.

The physical beauty of California is as varied as its populace. Travels along the coast offer the charm of seemingly endless beaches and spectacular cliffs that overlook sparkling Pacific vistas where surfers and dolphins share the waves. Lighthouses stand as silent reminders of maritime history, while the state's three largest cities—Los Angeles, San Diego and San Francisco—continue to write tomorrow's chronicles.

Inland, the traveler finds fertile valleys nestled between vast deserts and snow-capped mountains, forbidding obstacles that once demanded great fortitude from pioneers heading West to seek their fortunes. Today, these barriers provide recreational playgrounds for active people who hike, camp and ski, and provide tranquility to those who seek solace in the serenity of the wilderness or the comfort of the sun-basked beach.

People never stop coming to California. They come to work, to study, to establish their own permanence in the state's mild climate and vibrant lifestyle. Why would they not come? California offers boundless choices for the enterprising, the active, the intellectual and the creative.

<div align="right">

Jean Stern
Executive Director
The Irvine Museum

</div>

Kalifornien ist viel mehr als eine Ortsbezeichnung – es steht für einen Lifestyle und zugleich für eine Gegend, wo sich geniale künstlerische und unternehmerische Persönlichkeiten der Gesellschaft verwirklichen können. In der ganzen Welt gilt Kalifornien als der Ort, an dem erstaunliche Dinge erfunden und entwickelt werden. Es ist ein wundersamer Garten, in dem alles Mögliche wächst, und der magische Schauplatz, an dem Filme produziert werden.

Schon immer haben die unbegrenzten Möglichkeiten Kaliforniens zahllose Neuankömmlinge angelockt, angefangen bei den amerikanischen Ureinwohnern, denen dann andere folgten: Die Konquistadoren im 16. Jahrhundert ebenso wie die Padres im achtzehnten und neunzehnten Jahrhundert, welche die 21 Missionen erbauten, die verstreut sind von San Diego bis etwas nördlich von San Francisco. Während des Goldrauschs im Jahre 1849 strömten Scharen von Glückssuchenden in die Sierras, und die Jahre nach dem Zweiten Weltkrieg läuteten einen weiteren Populationsboom ein. Das Leben im bevölkerungsreichsten Bundesstaat der Vereinigten Staaten hat eine so starke Dynamik, dass Kalifornien – wäre es ein eigenständiges Land – die achtgrößte Wirtschaftsmacht der Welt wäre.

Die landschaftliche Schönheit Kaliforniens ist so vielfältig wie seine Einwohner. Entlang der Küste erlebt der Reisende den Zauber scheinbar endloser Strände und spektakulärer Klippen, die einen Ausblick auf den glitzernden Pazifik bieten, wo sich Surfer und Delfine gemeinsam in den Wellen tummeln. Leuchttürme erinnern an die maritime Vergangenheit, während die drei größten Städte des Bundesstaates – Los Angeles, San Diego und San Francisco – fleißig an den Chroniken von morgen schreiben.

Im Landesinnern findet der Reisende fruchtbare Täler eingebettet zwischen weiten Wüsten und schneebedeckten Bergen; unwirtliche Hindernisse, die einst den Pionieren, die gen Westen zogen, um dort ihr Glück zu machen, das Äußerste abverlangten. Heute präsentieren sich die einstigen Barrieren als Freizeitparadiese, wo aktive Menschen wandern, campen oder Ski fahren, und bieten Stille und Frieden für all jene, welche die Ruhe der Wildnis oder die Behaglichkeit des sonnenverwöhnten Strands suchen.

Die Menschen hören nicht auf, nach Kalifornien zu strömen. Sie kommen, um im milden Klima und dem pulsierenden Lifestyle dieses Staates zu arbeiten, zu studieren oder um sich hier niederzulassen. Und warum sollten sie das auch nicht tun? Kalifornien bietet grenzenlose Möglichkeiten für alle Unternehmungslustigen, Aktiven, Intellektuellen und Kreativen.

Jean Stern
Verantwortlicher Direktor
Irvine Museum

La Californie représente beaucoup plus que la désignation d'un lieu : elle symbolise à la fois un style de vie et une région où le génie des personnalités artistiques et économiques de la société peut se concrétiser. La Californie est considérée dans le monde entier comme un endroit favorisant la découverte et la création de choses étonnantes. C'est un jardin merveilleux dans lequel prospère tout ce que l'on peut imaginer, ainsi qu'un décor magique pour la production des films.

Les possibilités illimitées qu'offre la Californie ont toujours attiré de nombreux nouveaux arrivants, à commencer par les autochtones américains, suivis par d'autres : les conquistadors au 16ème siècle, tout comme les Padres aux dix-huitième et dix-neuvième siècles qui construisirent 21 missions, réparties de San Diego jusqu'environ au nord de San Francisco. Pendant la ruée vers l'or en 1849, des groupes d'individus à la recherche de leur bonheur affluent vers la Sierra, et les années suivant la seconde guerre mondiale marquent le début d'un nouveau boom de la population. La vie dans l'état fédéral le plus peuplé des Etats-Unis a une dynamique si forte que la Californie, si elle était un pays indépendant, serait la huitième puissance économique mondiale.

La beauté du paysage de la Californie est aussi diversifiée que ses habitants. Le long de la côte, le voyageur découvre la magie des plages semblant s'étirer à l'infini et des rochers spectaculaires qui offrent une vue sur l'océan pacifique scintillant, là où les surfeurs et les dauphins s'ébattent ensemble dans les vagues. Les phares rappellent le passé maritime, tandis que les trois villes les plus importantes de l'état fédéral - Los Angeles, San Diego et San Francisco – écrivent assidûment les chroniques de demain.

A l'intérieur du pays, le voyageur trouve des vallées fertiles, encadrées de grands déserts et de montages enneigées ; ce sont ces obstacles inhospitaliers qui demandèrent autrefois l'impossible aux pionniers partis en direction de l'Ouest pour tenter leur chance. Aujourd'hui, les anciennes barrières se présentent à nous comme des paradis de loisirs où les personnes actives effectuent des randonnées, campent ou font du ski, offrant la tranquillité et la paix à tous ceux qui recherchent le calme d'une contrée sauvage ou l'atmosphère de bien-être des plages inondées de soleil.

Les hommes ne cessent d'affluer vers la Californie. Ils sont attirés par le climat doux et le style de vie trépidant de cet état pour y travailler, y étudier ou s'y installer. Et pourquoi pas ne devraient-ils pas le faire? La Californie offre des possibilités sans limites pour tous les individus entreprenants, actifs, intellectuels et créatifs.

Jean Stern
Directeur responsable
Irvine Museum

California es mucho más que el nombre de un estado; es sinónimo de un estilo de vida y el escenario donde las geniales personalidades artísticas y empresariales de la sociedad se desarrollan con libertad. Para el mundo, California es el lugar donde se inventan las más asombrosas cosas. Es un raro jardín donde crece la más variada vegetación y un plató mágico en el que se realizan películas.

Desde siempre, innumerables forasteros se han sentido atraídos por las infinitas posibilidades de California. Al principio fueron los indígenas americanos, después, en el siglo XVI, les siguieron los conquistadores y, entre los siglos XVIII y XIX, llegaron los padres, que levantaron 21 misiones desde San Diego hasta el norte de San Francisco. Durante la fiebre del oro del año 1849, miles de personas se dirigieron en masa hacia las sierras buscando fortuna y, en los años posteriores a la Segunda Guerra Mundial, se produjo una nueva explosión demográfica. La vida en el estado federado más poblado de los Estados Unidos es de tal dinamismo que, si California fuera un país independiente, se situaría entre las ocho mayores economías del mundo.

La belleza paisajística de California es tan variada como sus habitantes. A lo largo de la costa, el viajero experimenta la magia de las infinitas playas y los espectaculares arrecifes, que ofrecen una maravillosa vista sobre el brillante Pacífico donde los amantes del surf y los delfines se confunden con las olas. Los faros evocan el pasado marinero mientras que las tres mayores ciudades del estado, Los Ángeles, San Diego y San Francisco, escriben las crónicas del mañana.

En el interior, el viajero se encuentra con fértiles valles rodeados de extensos desiertos y montañas cubiertas de nieve; territorios inhóspitos que exigieron un elevado precio a los pioneros que se dirigieron al Oeste para buscar fortuna. Las barreras de antaño se han convertido hoy en paraísos del tiempo libre para todos aquellos que quieren practicar el senderismo, la acampada o el esquí. Pero también ofrecen lugares de paz y tranquilidad para los que buscan el sosiego de la naturaleza o el descanso de las soleadas playas.

La gente no cesa de llegar a California. Atraídos por el suave clima y el palpitante estilo de vida de este estado, vienen para trabajar, para estudiar o para quedarse. ¿Por qué no? California ofrece infinitas posibilidades para los emprendedores, para los intelectuales, para las personas activas y para las creativas.

Jean Stern
Director responsable
Museo Irvine

La California è molto di più che un luogo: sta ad indicare uno stile di vita e al contempo una regione in cui personalità ingegnose, artistiche e intraprendenti possono realizzarsi. In tutto il mondo la California è conosciuta come il luogo in cui si inventano e sviluppano cose sorprendenti. È il giardino meraviglioso in cui cresce di tutto e il posto magico in cui si girano i film.

Da sempre le opportunità illimitate della California hanno attirato innumerevoli persone, a partire dagli indiani americani, a cui seguirono i conquistadores nel Cinquecento e poi i padri che nel Settecento e agli inizi dell'Ottocento costruirono 21 missioni sparse tra San Diego e la zona a nord di San Francisco. Durante la Febbre dell'oro del 1849 flotte di avventurieri in cerca di fortuna si riversarono nelle sierras, e dopo la seconda guerra mondiale ebbe inizio un altro boom demografico. La vita nello Stato federale più popoloso degli Stati Uniti è talmente dinamica che se la California fosse uno stato indipendente sarebbe l'ottava potenza economica mondiale.

La bellezza del paesaggio californiano è varia come i suoi abitanti. Le coste affascinano con le loro spiagge apparentemente sconfinate e spettacolari scogliere che si affacciano sullo scintillante Oceano Pacifico, dove i surfisti e i delfini scorrazzano insieme fra le onde. Fari ricordano il passato marinaro, mentre le tre maggiori città dello Stato federale, Los Angeles, San Diego e San Francisco, non smettono di dare il proprio contributo alle cronache di domani.

Nell'interno si trovano fertili vallate incastonate tra vasti deserti e montagne innevate, ostacoli minacciosi che un tempo rappresentavano una sfida per i pionieri diretti ad ovest in cerca di fortuna. Oggigiorno le barriere di un tempo sono il regno di escursionisti, campeggiatori e sciatori e offrono pace e tranquillità a coloro che cercano ristoro nella natura intatta o benessere sulle spiagge assolate.

Le persone continuano a venire in California. Ci vengono per lavorare, studiare o stabilirsi definitivamente in questo Stato dal clima mite e dallo stile di vita pulsante di attività. E perché non dovrebbero? La California offre illimitate possibilità per chi è intraprendente, dinamico, intellettuale o creativo.

Jean Stern
Direttore esecutivo
Irvine Museum

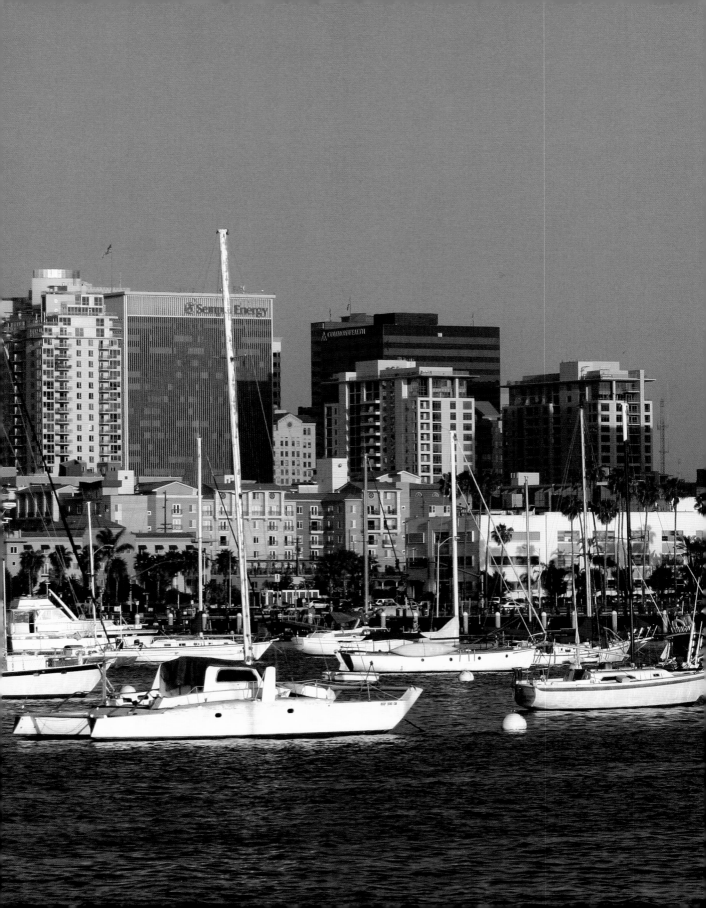

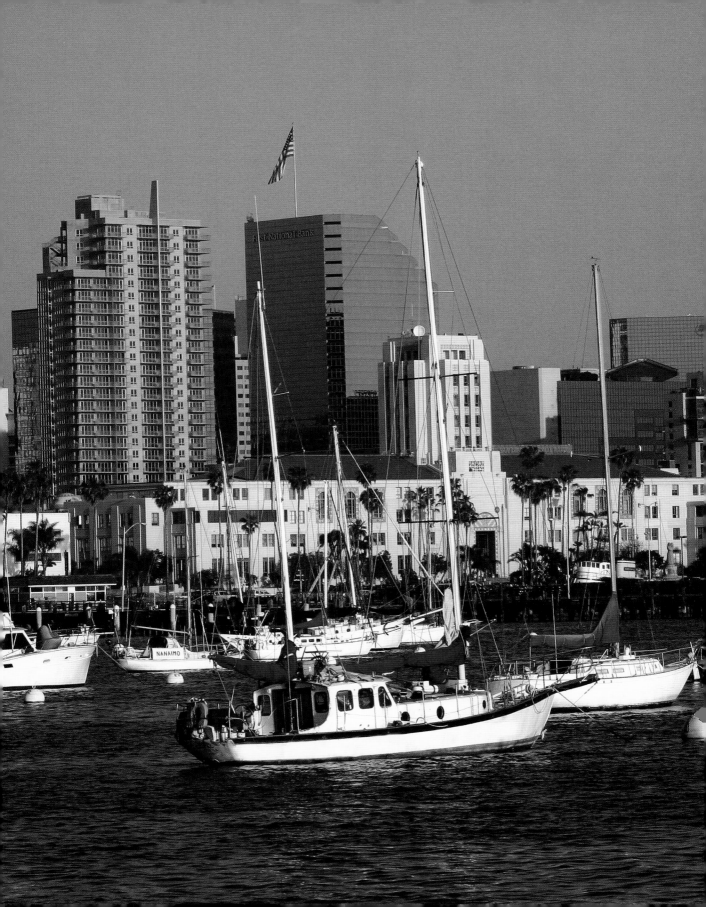

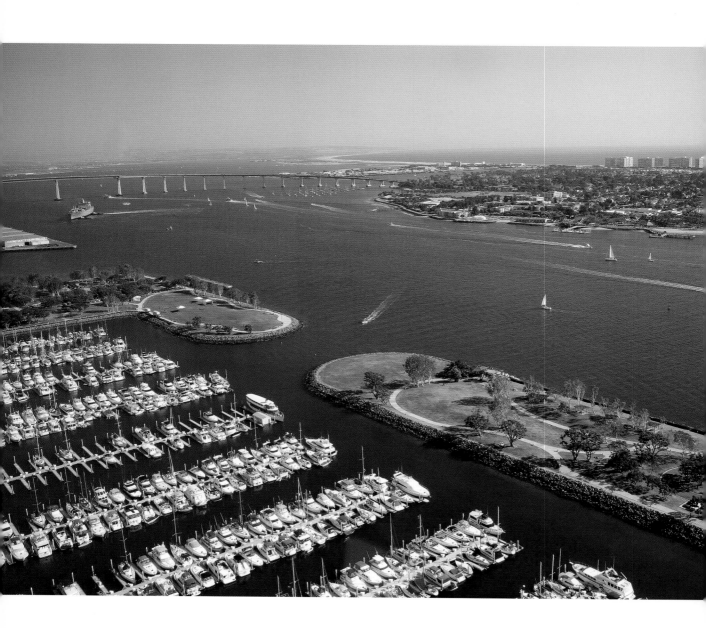

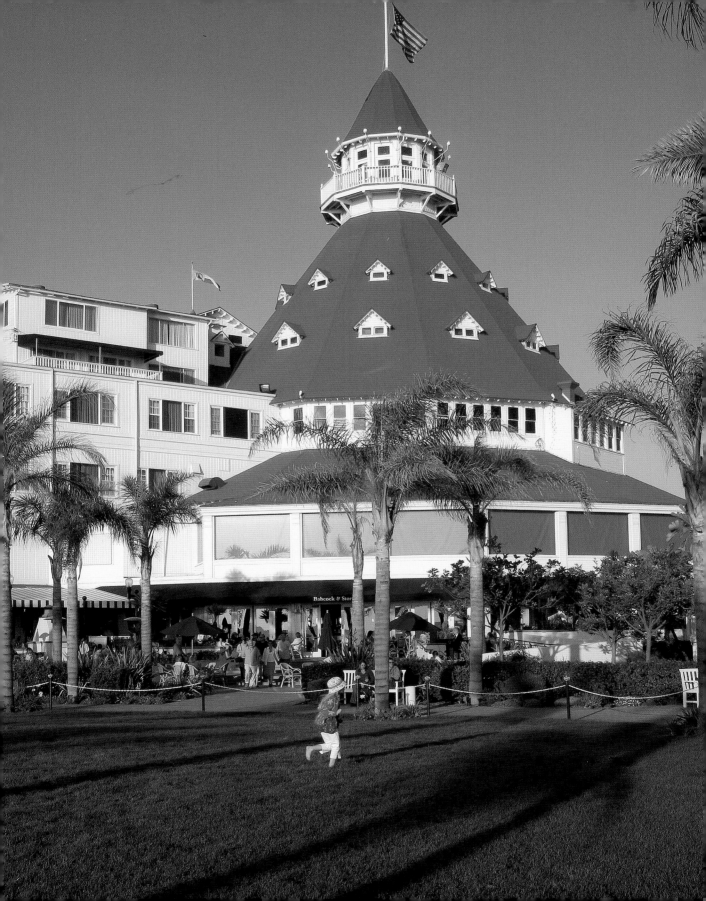

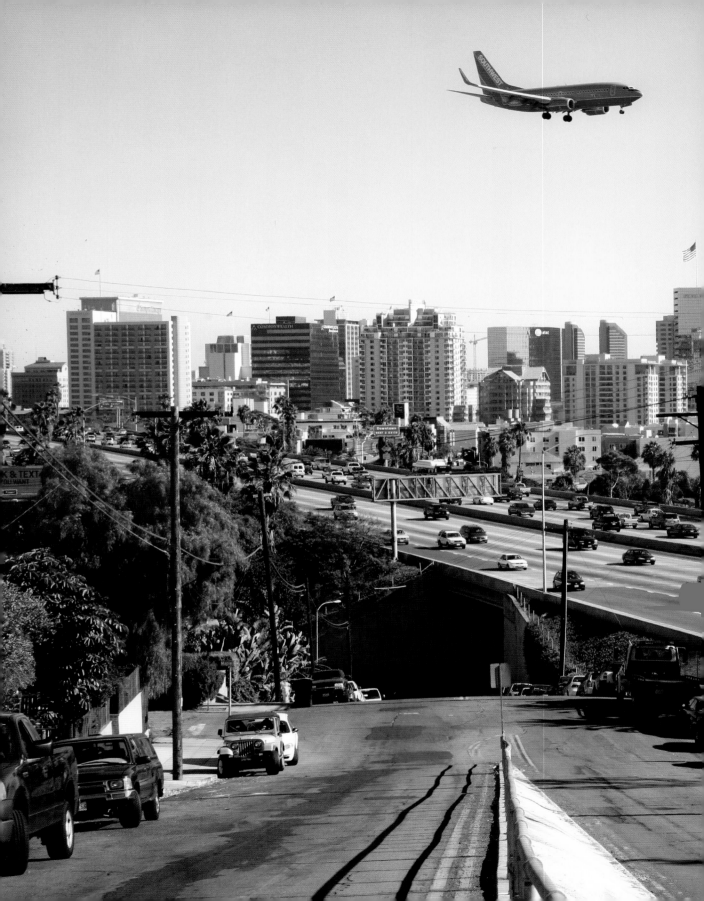

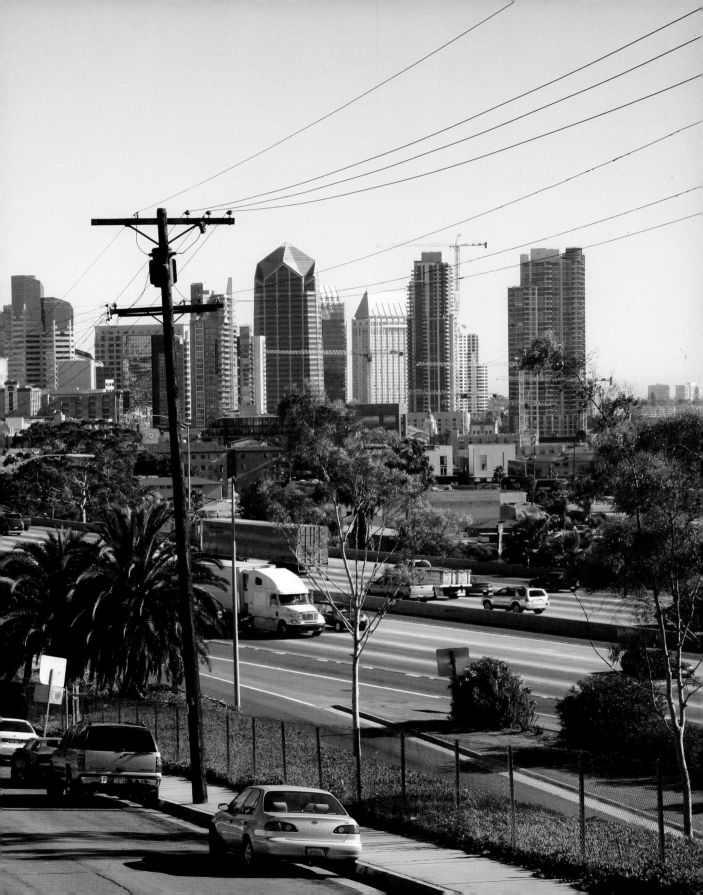

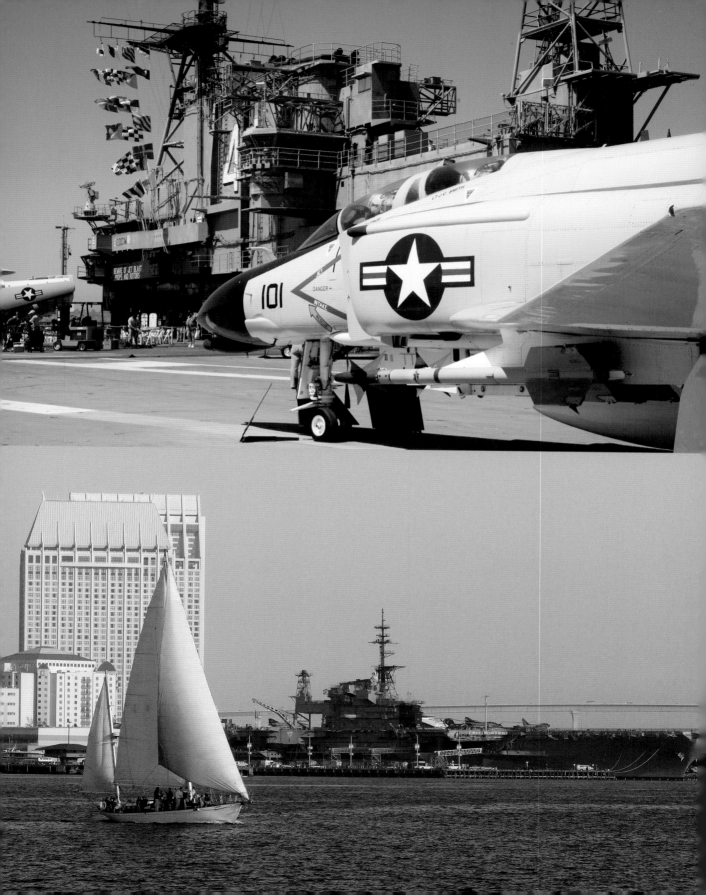

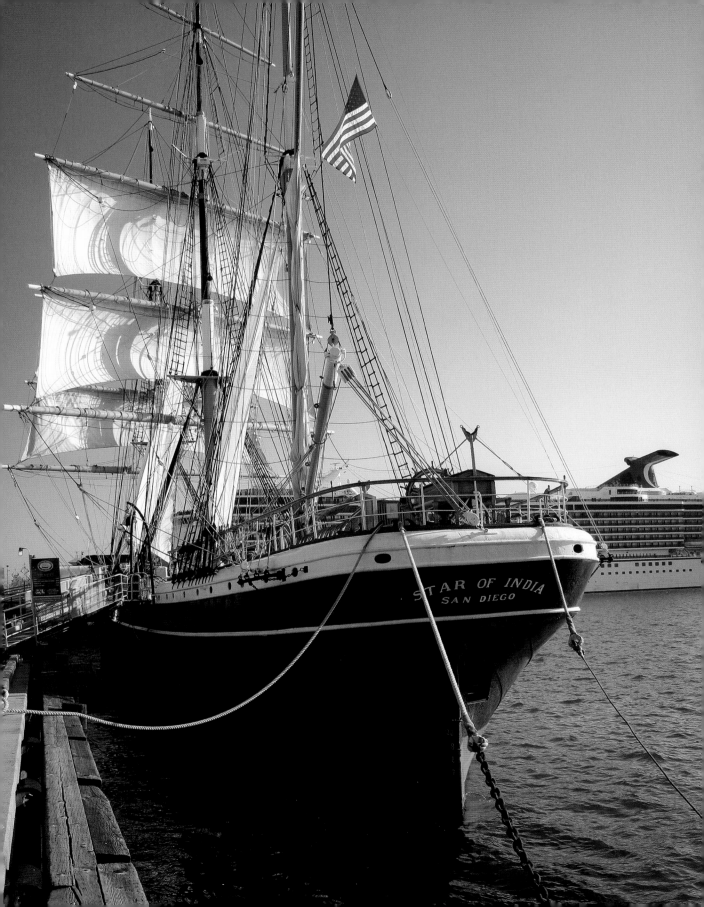

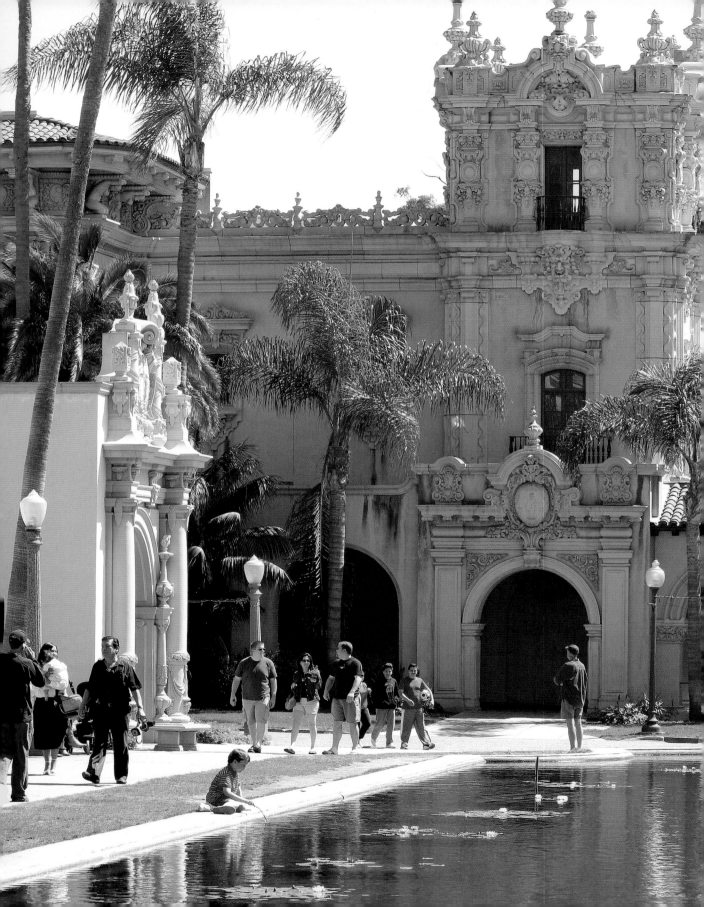

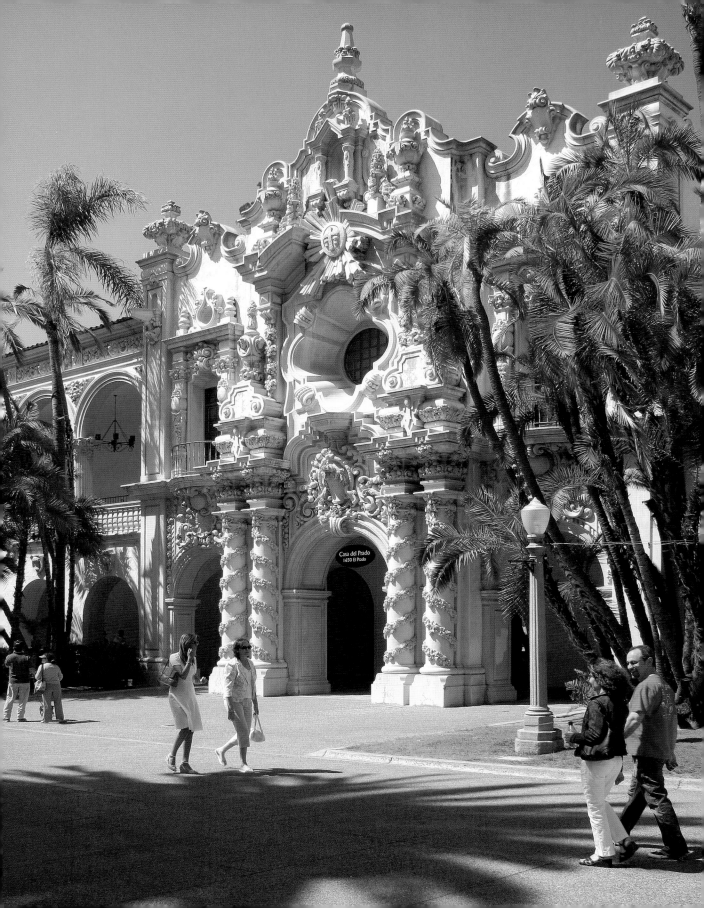

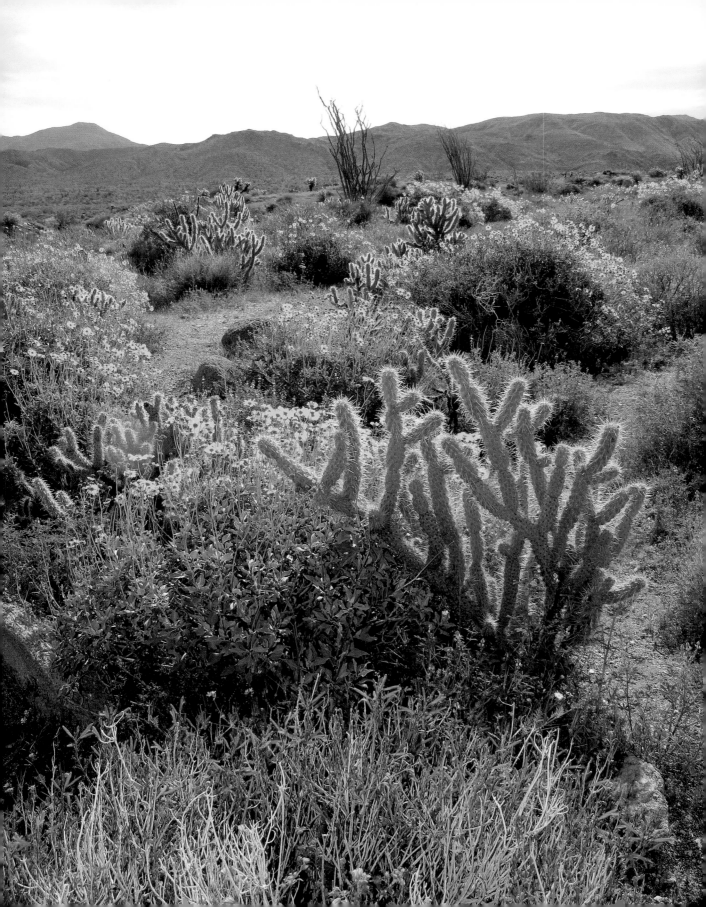

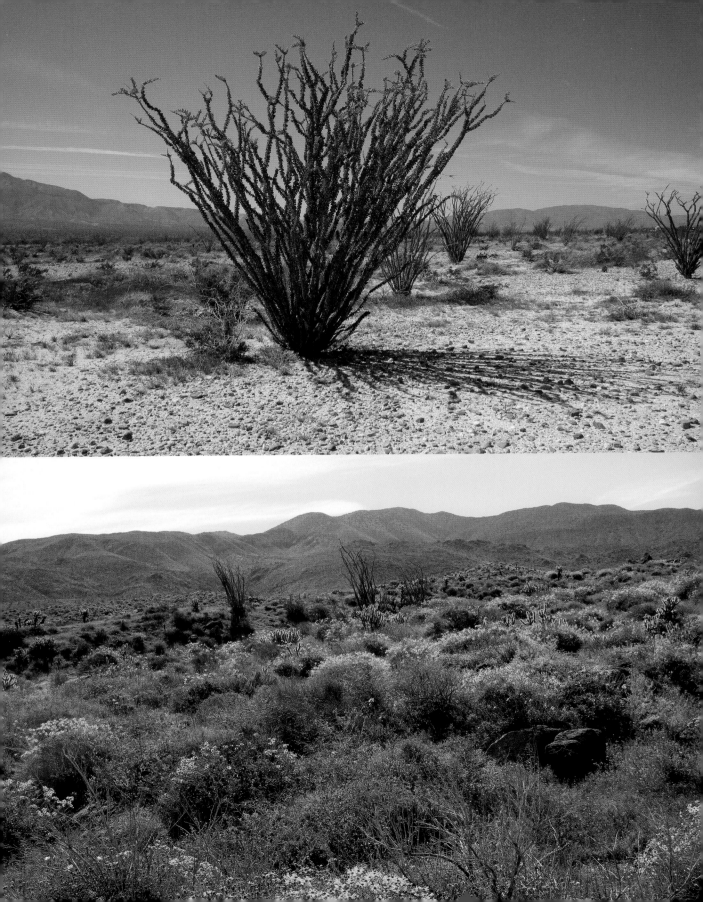

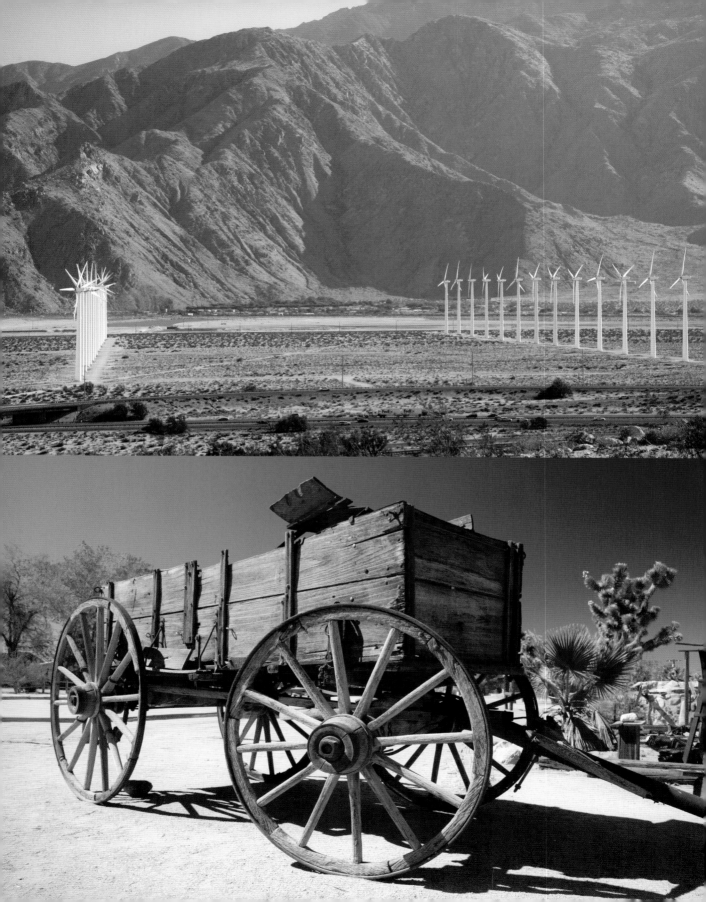

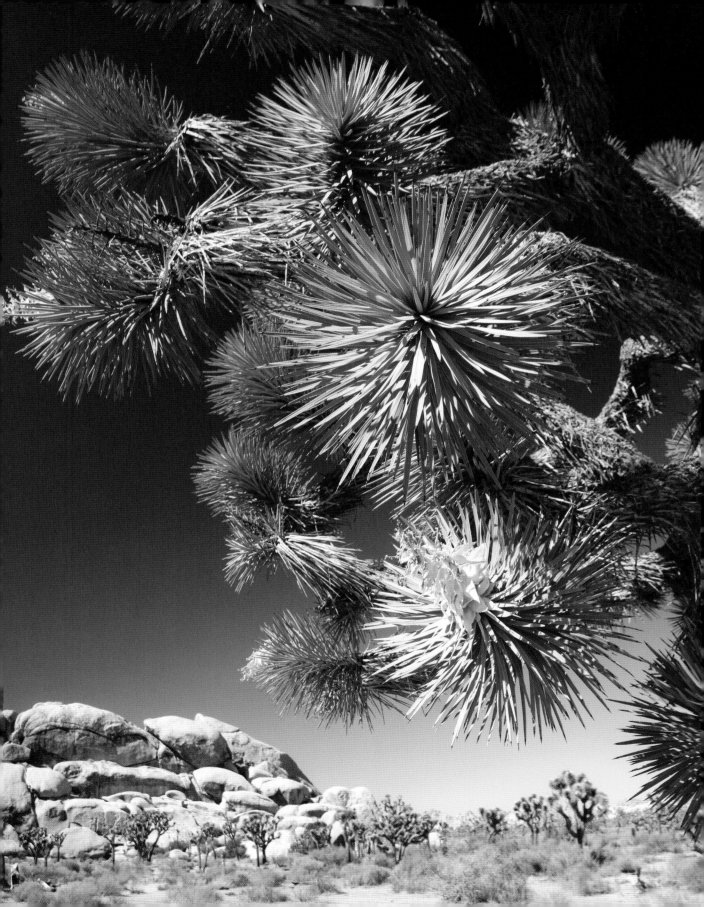

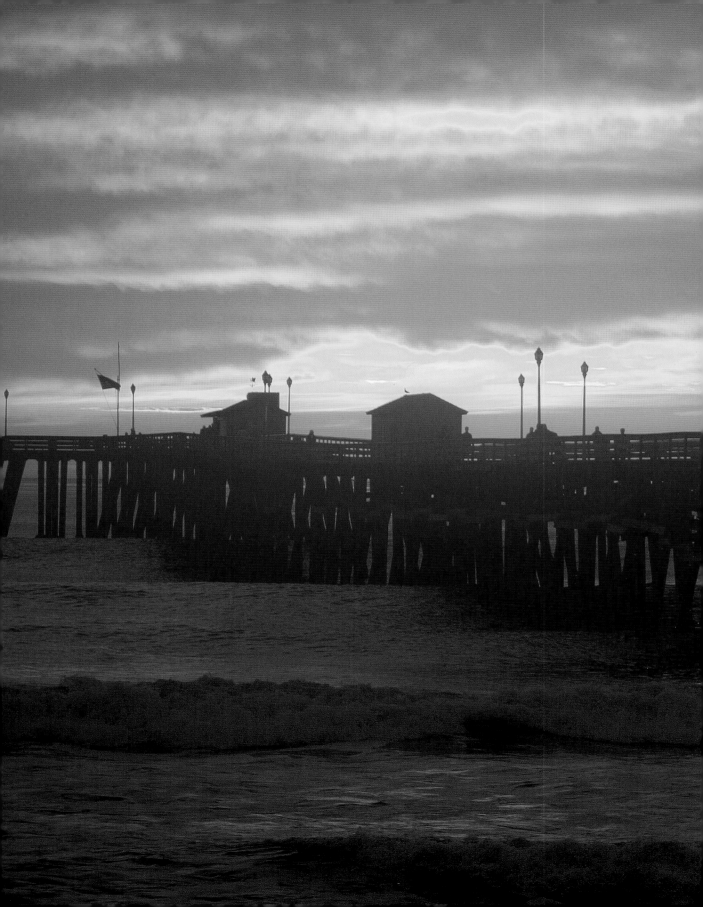

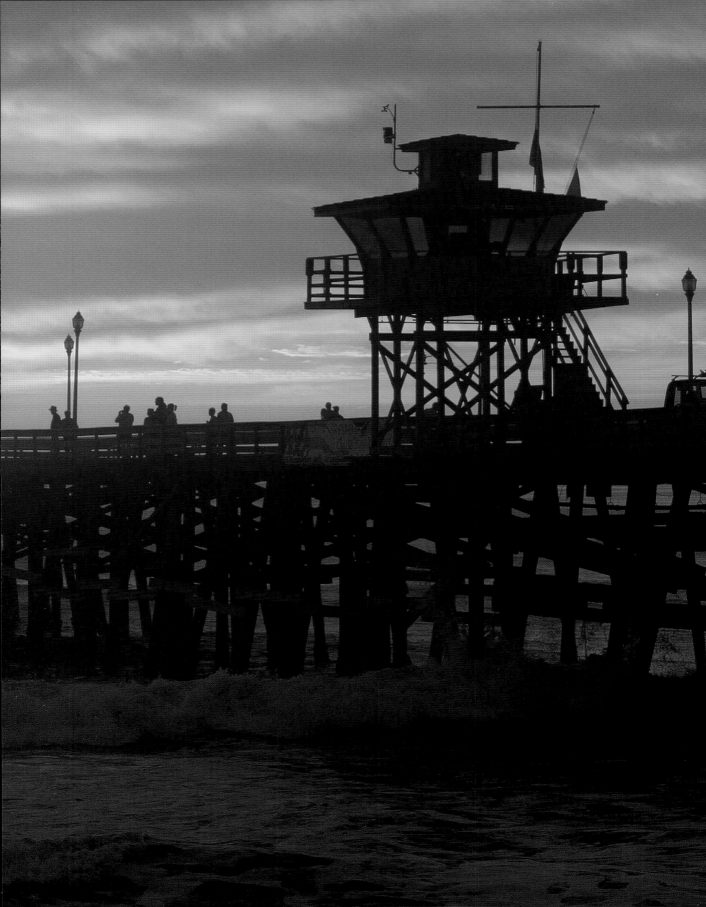

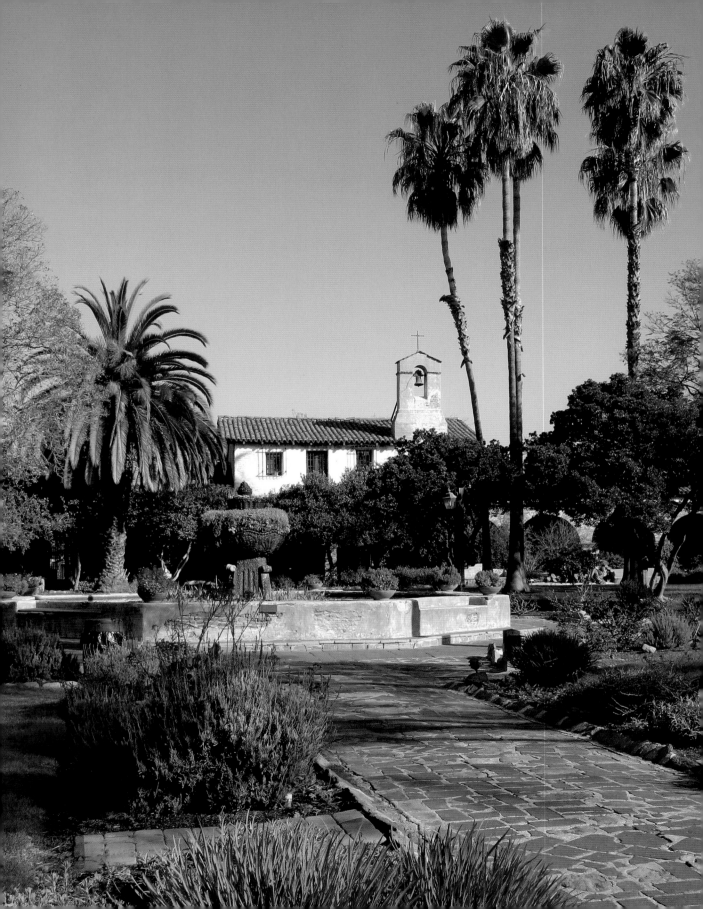

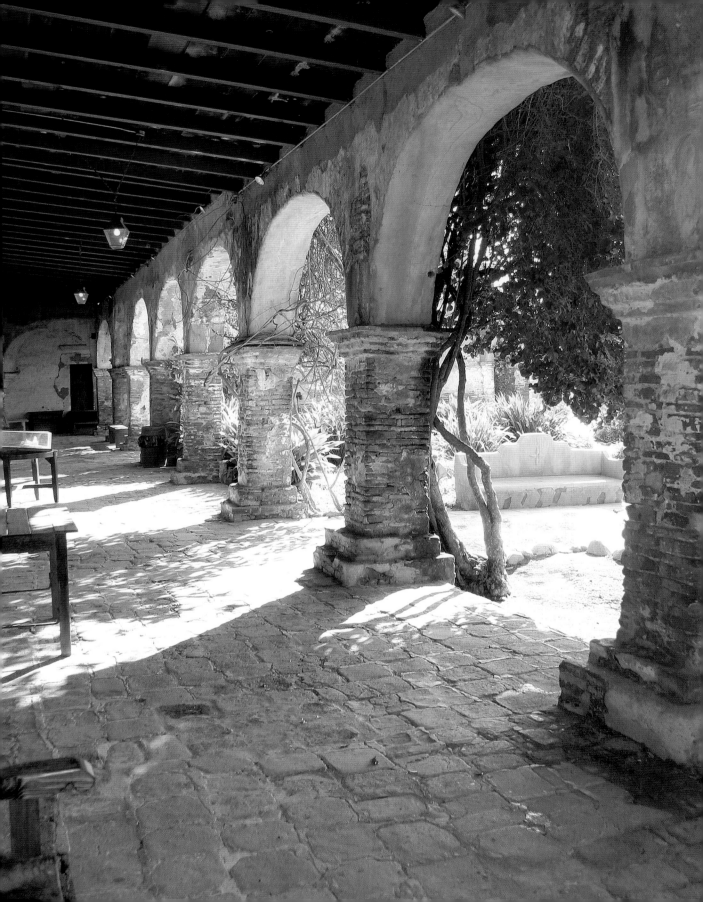

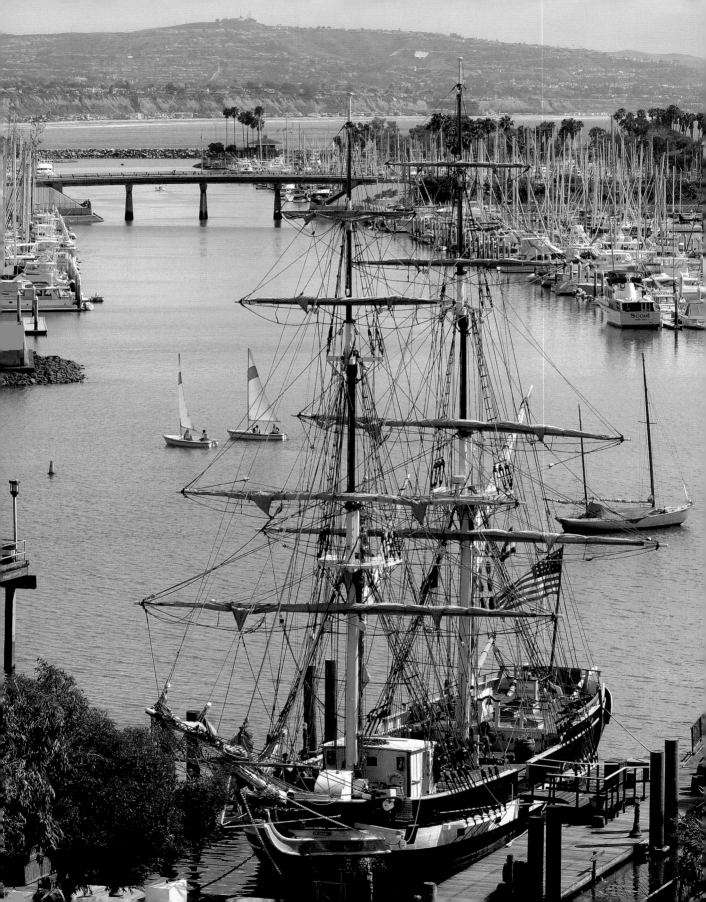

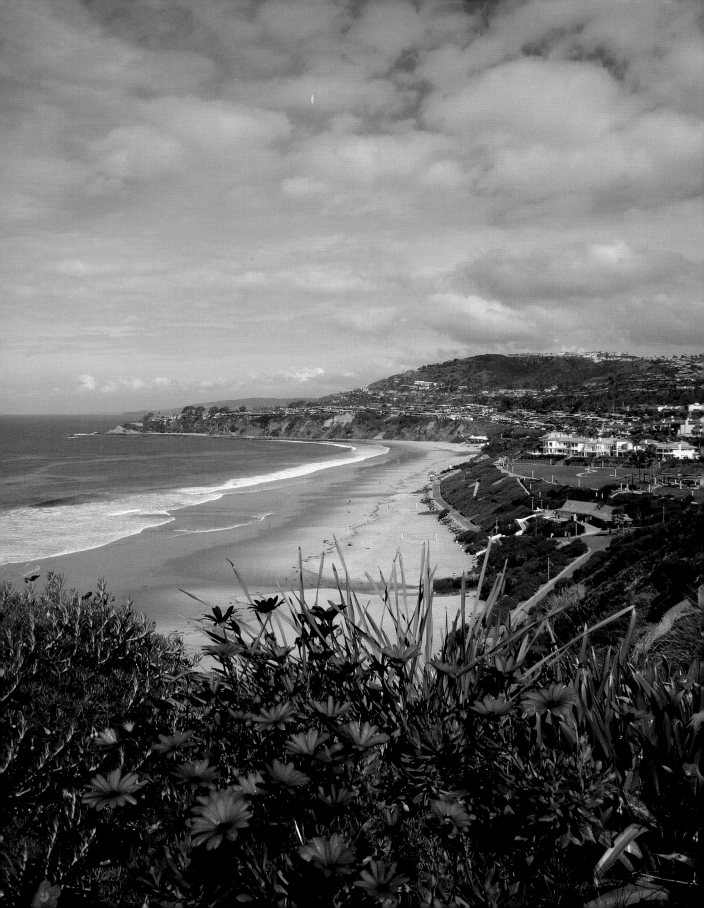

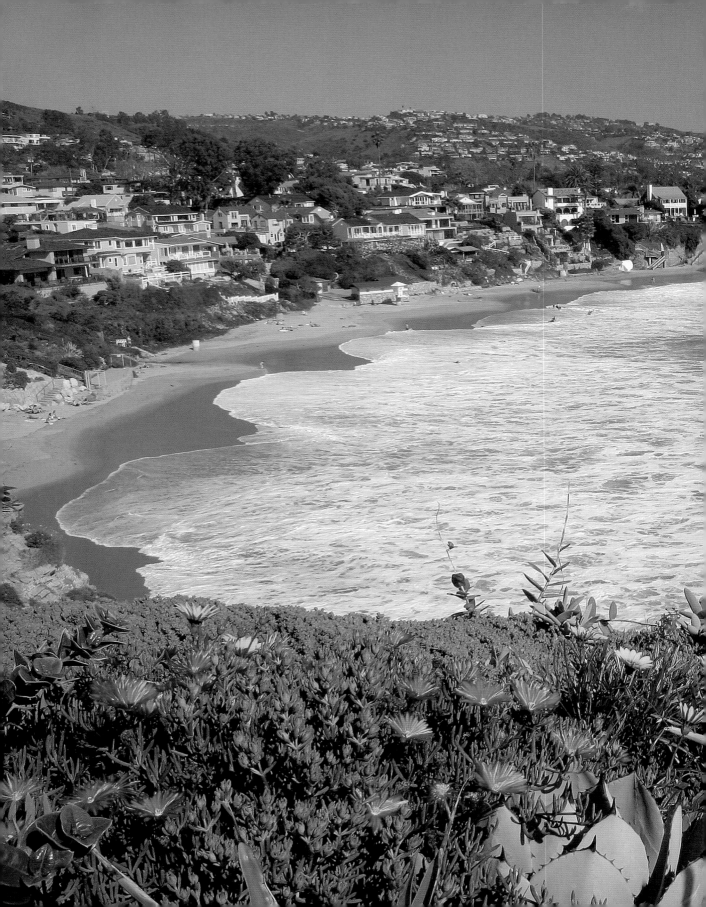

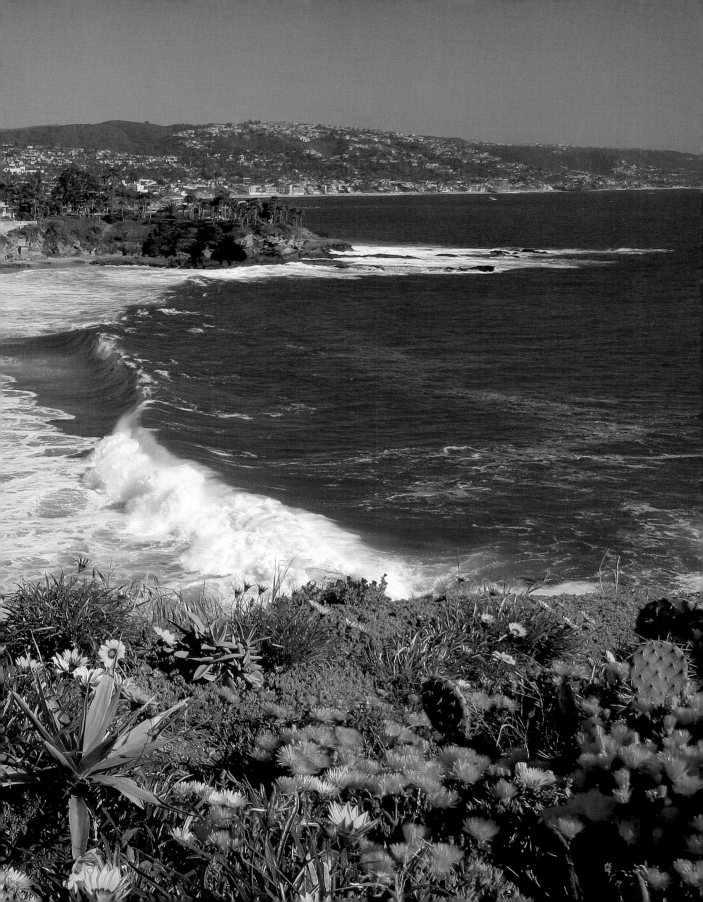

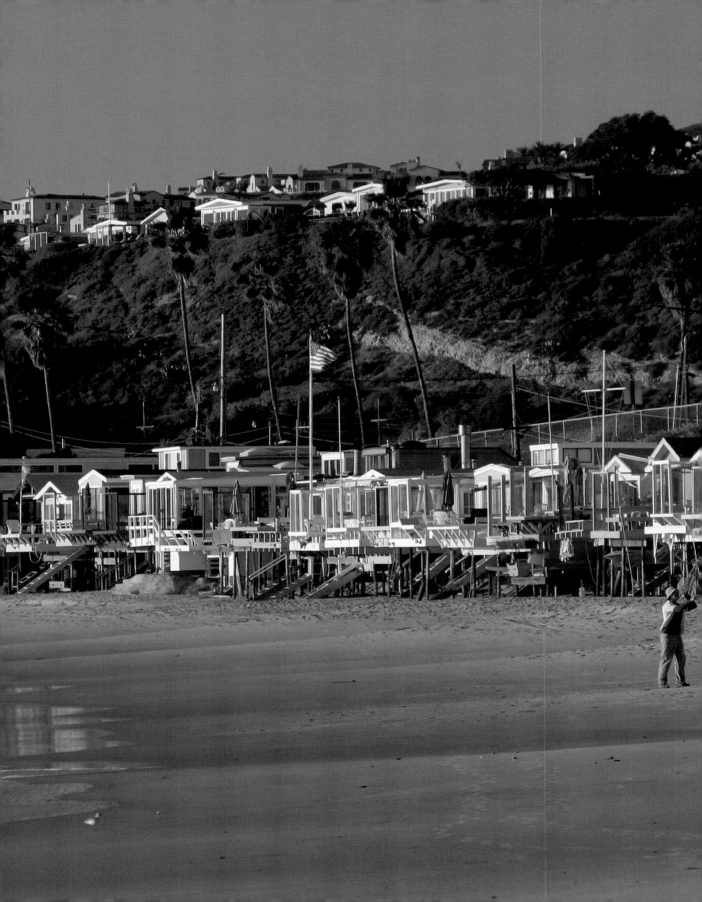

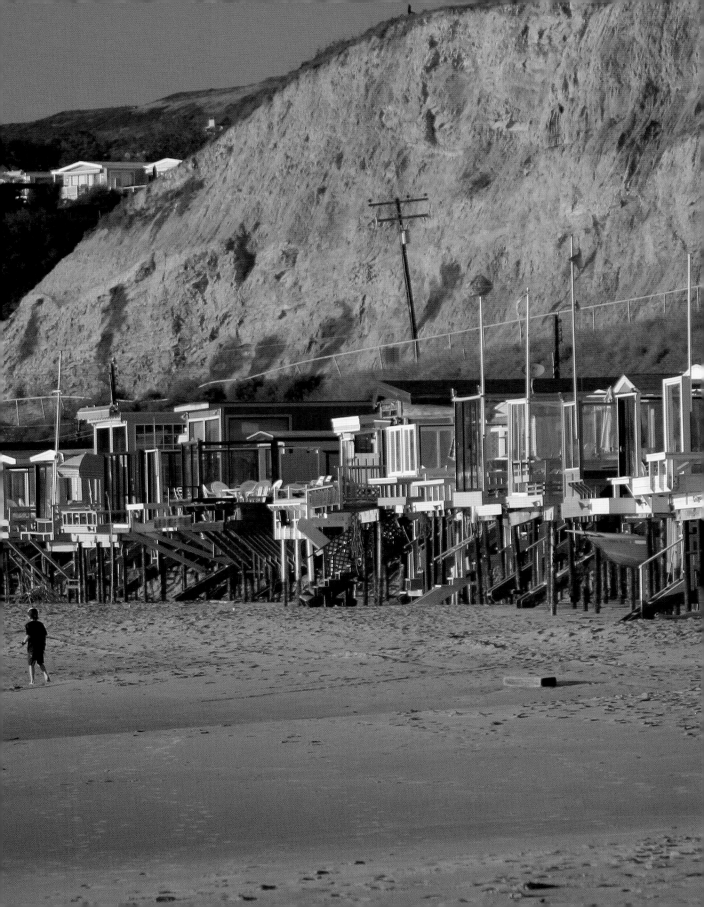

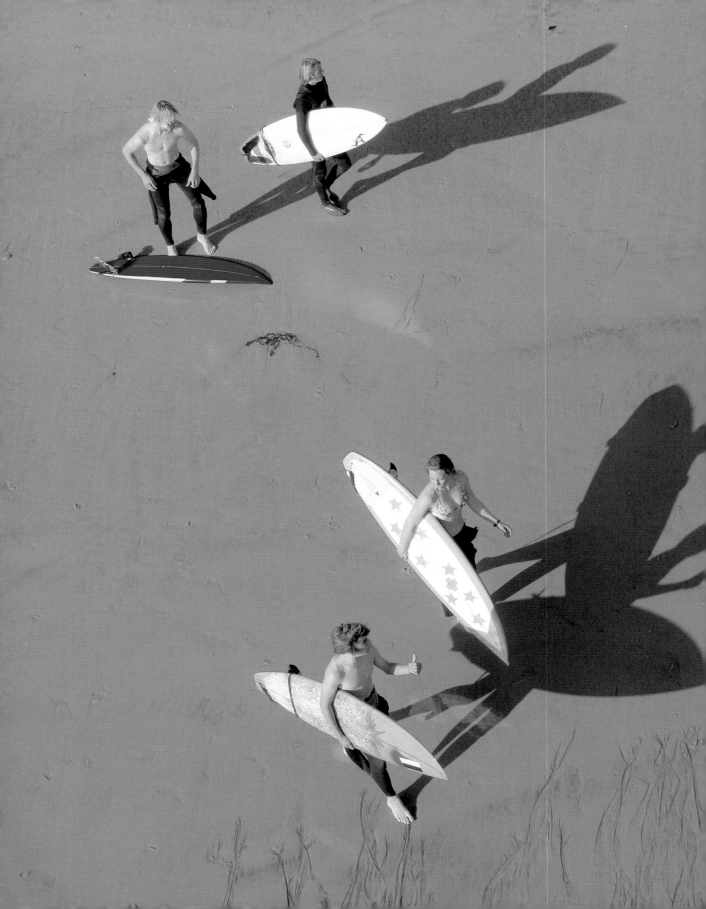

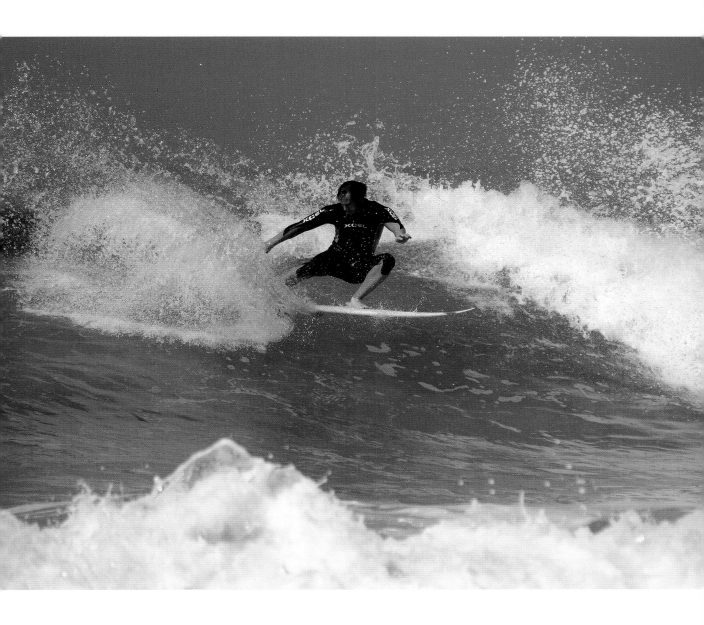

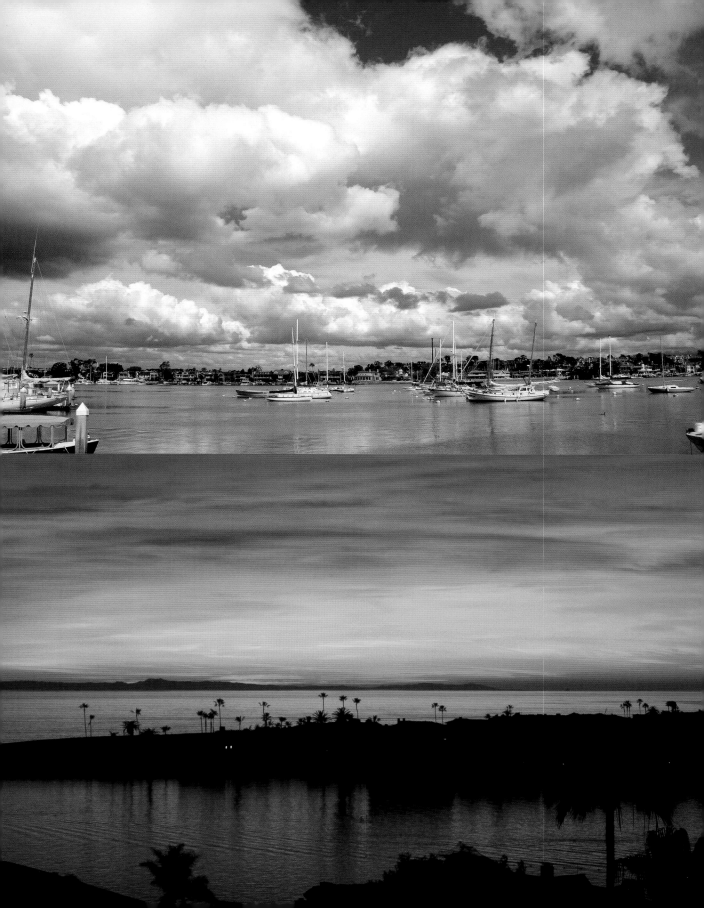

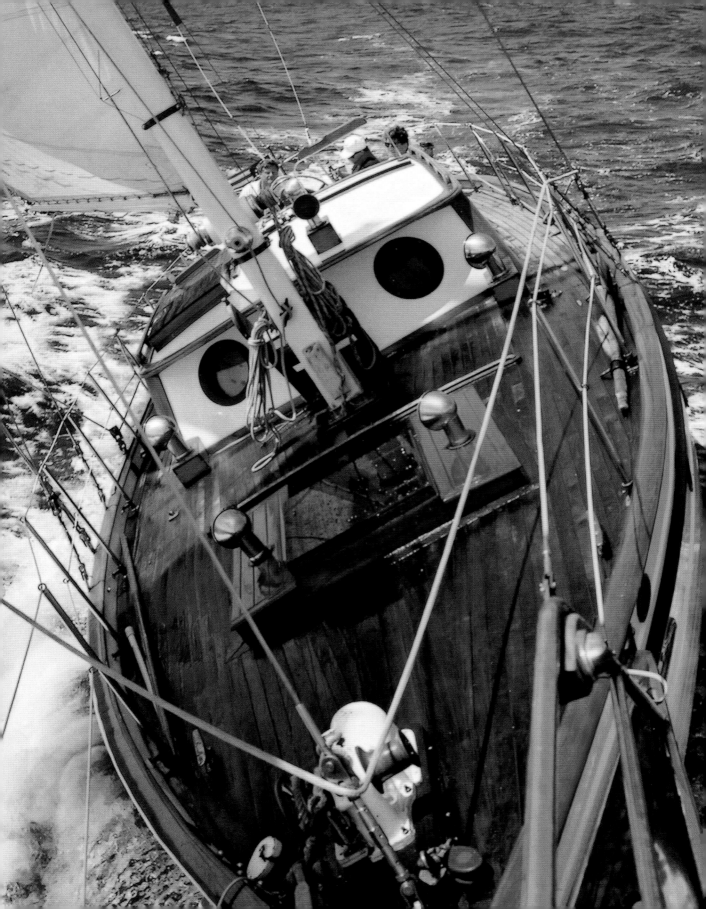

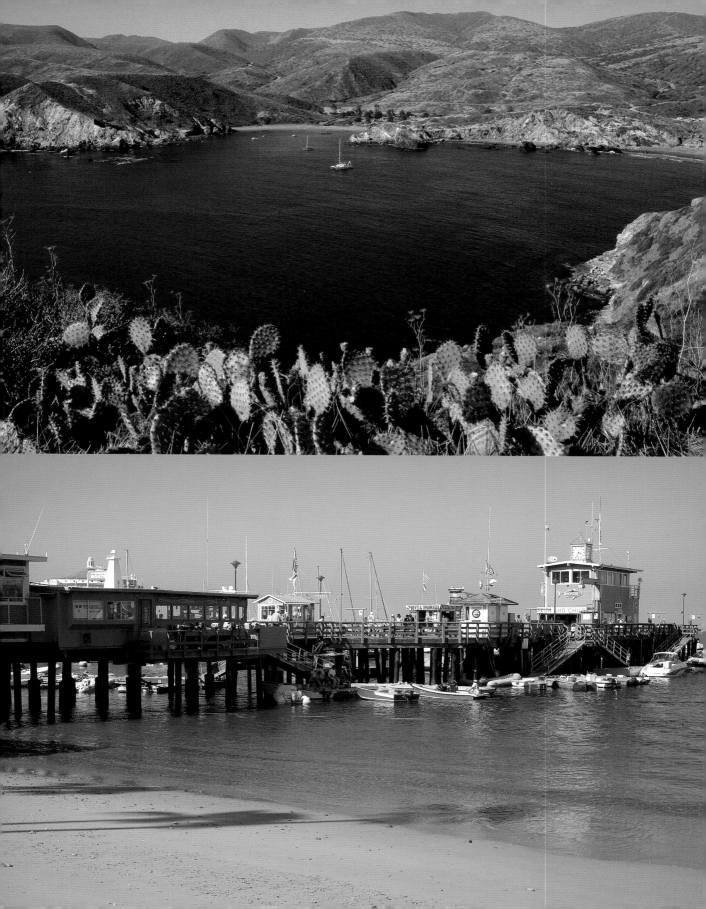

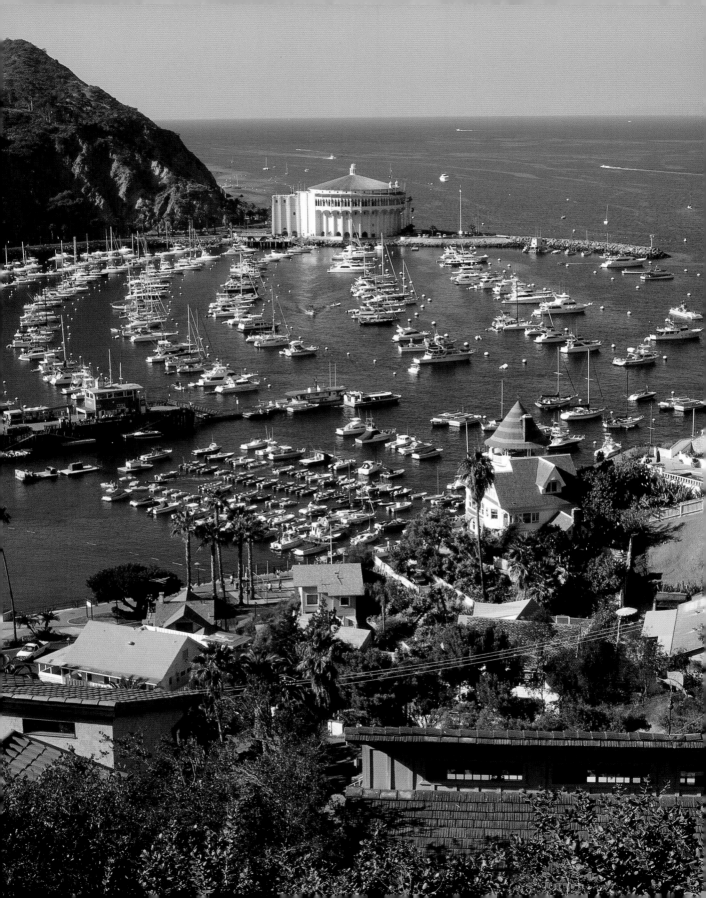

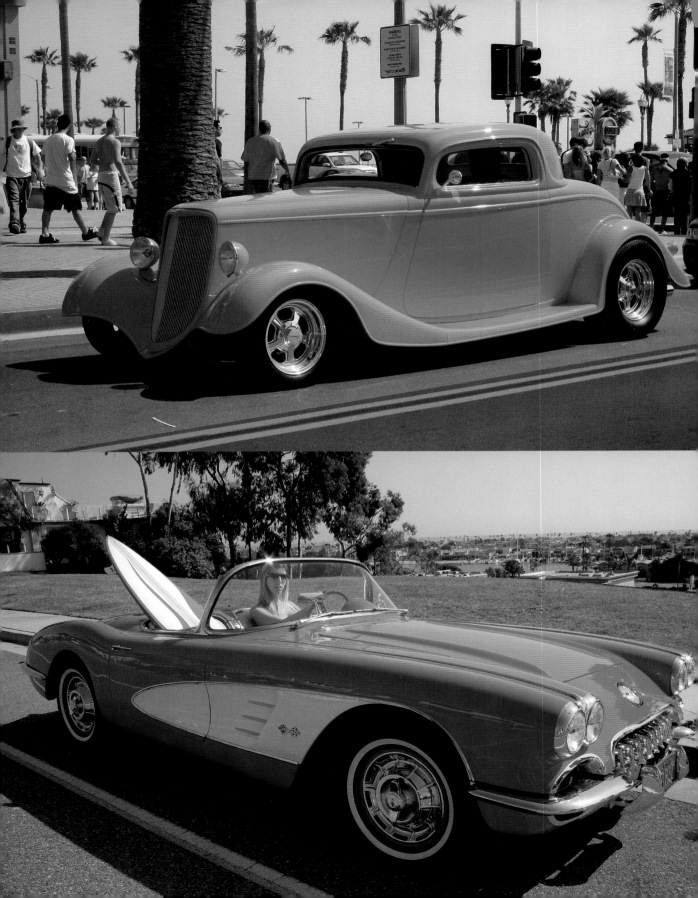

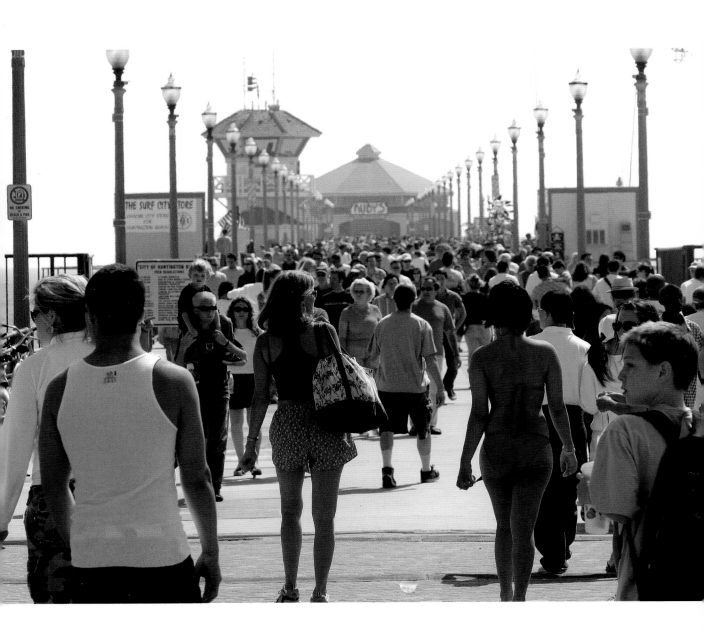

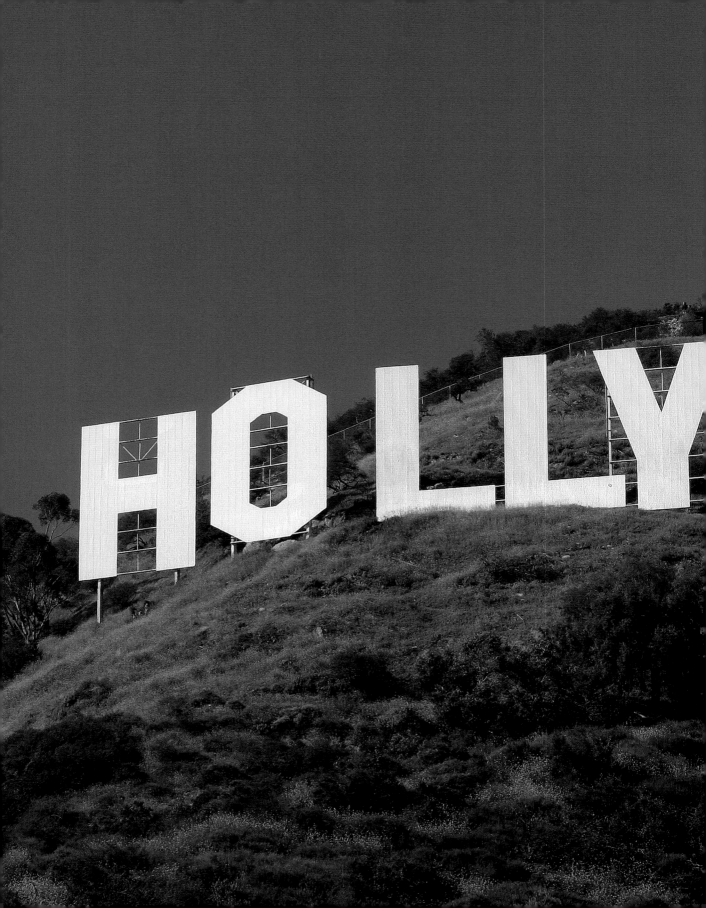

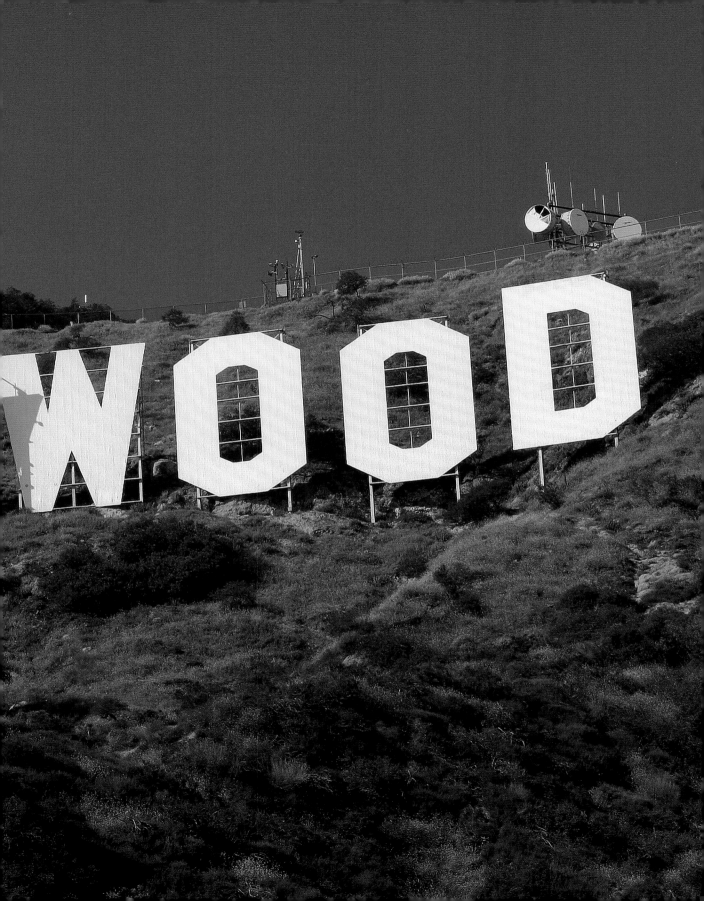

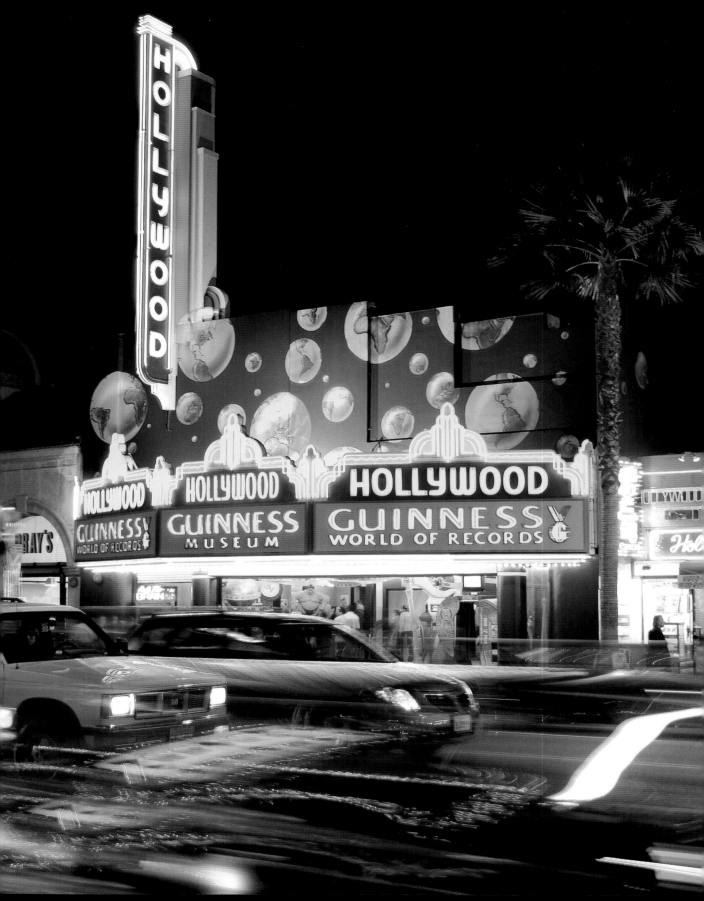

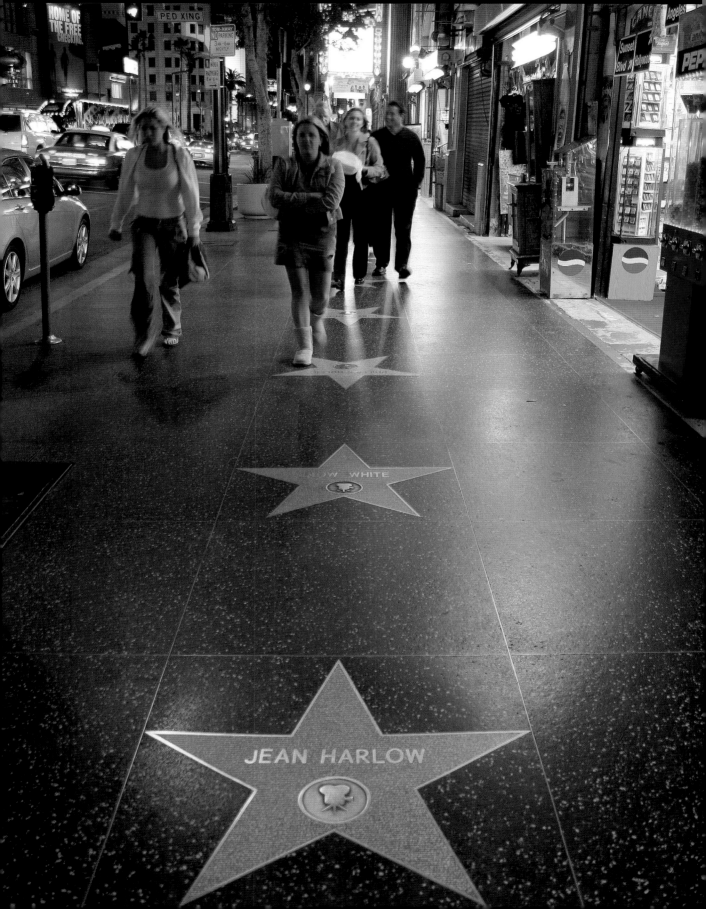

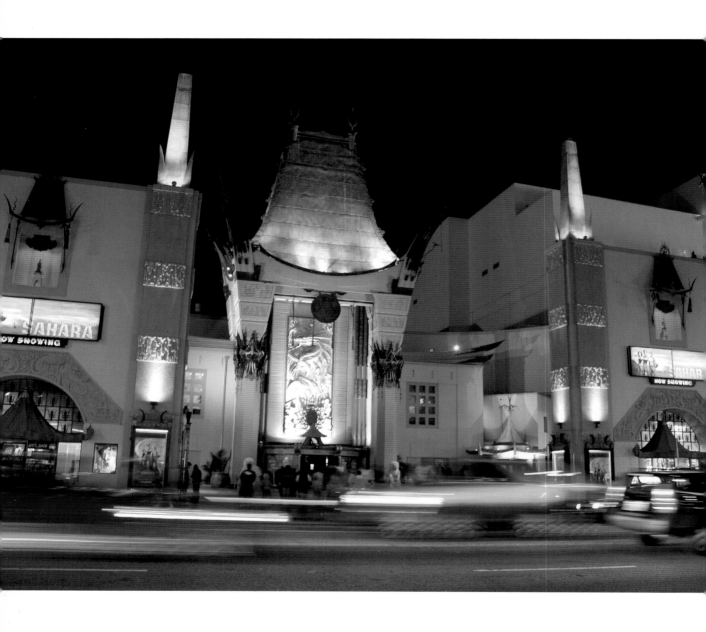

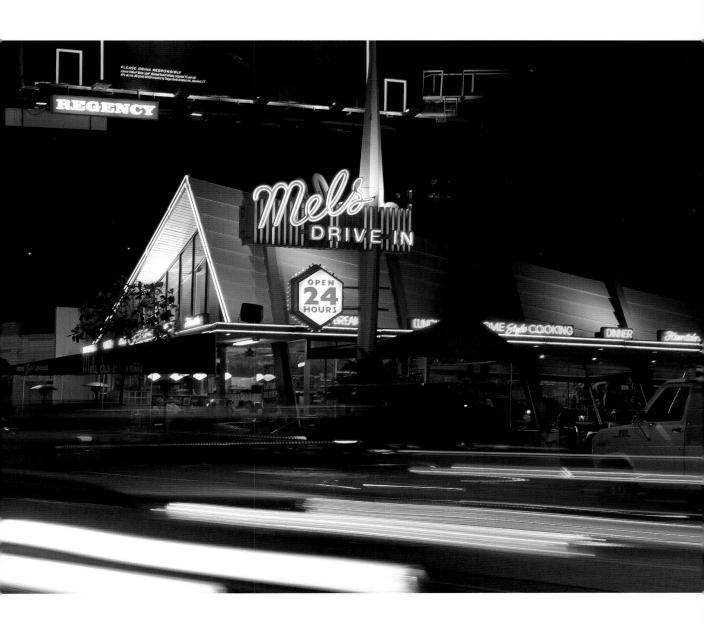

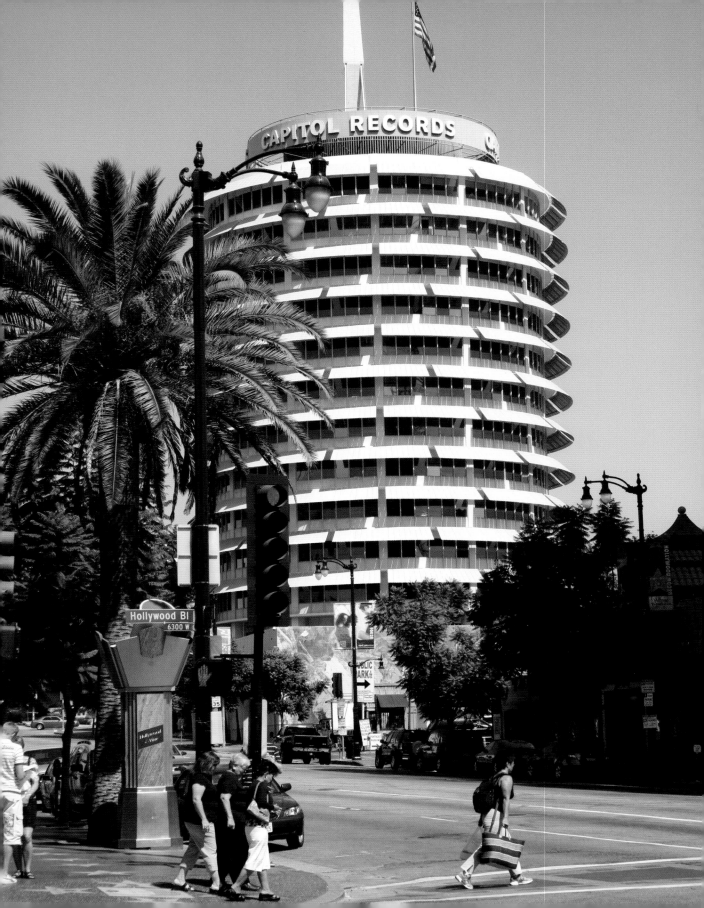

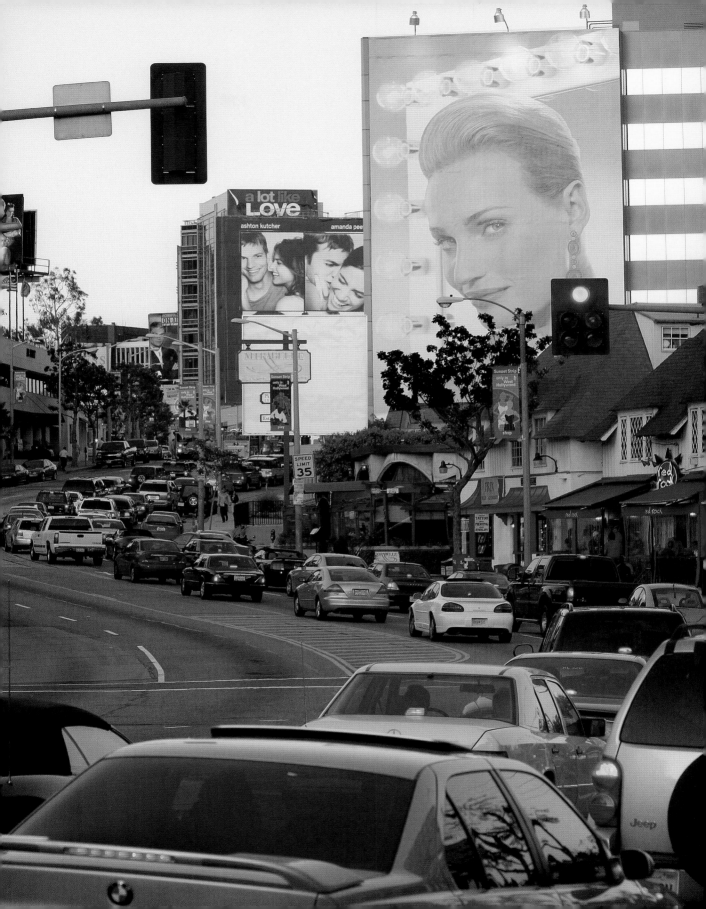

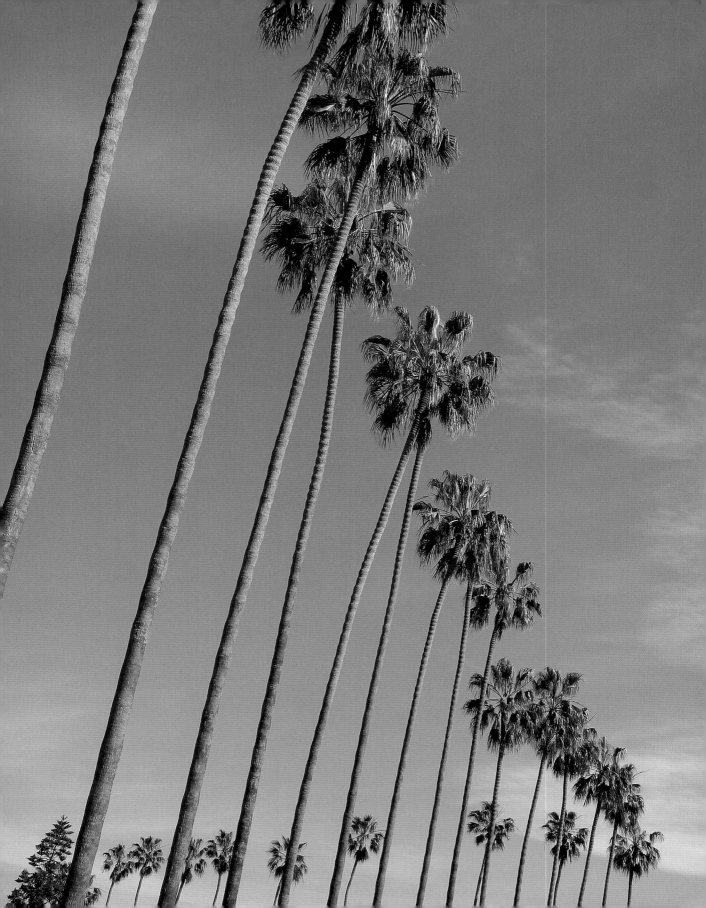

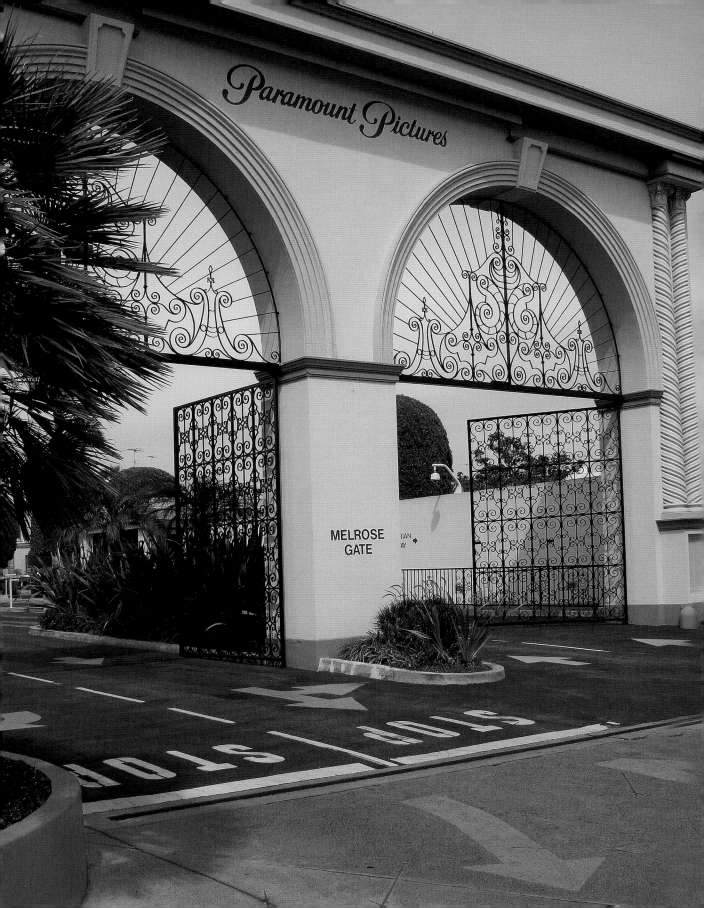

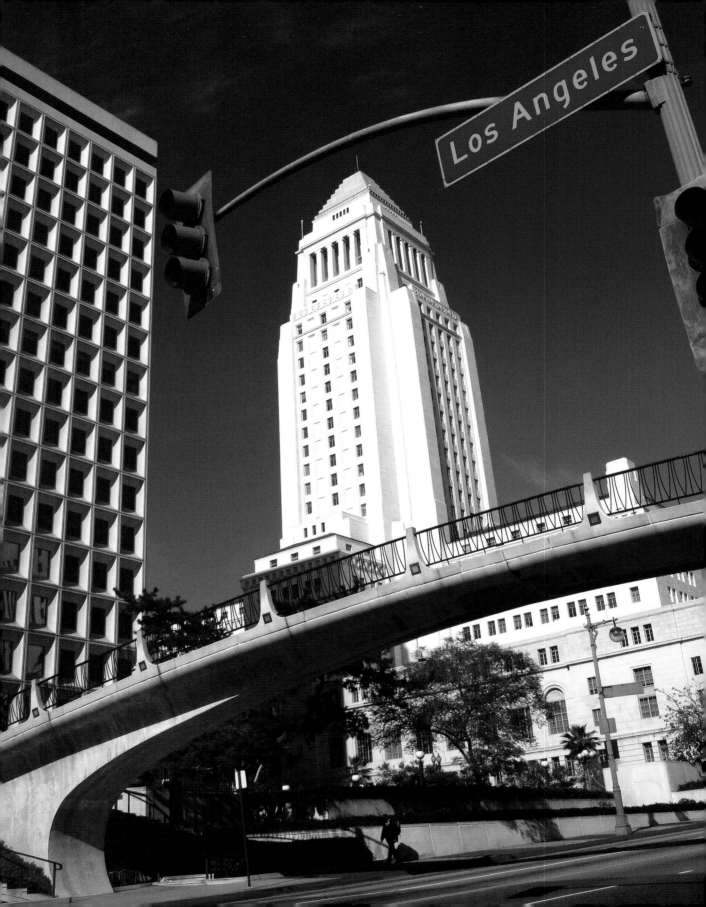

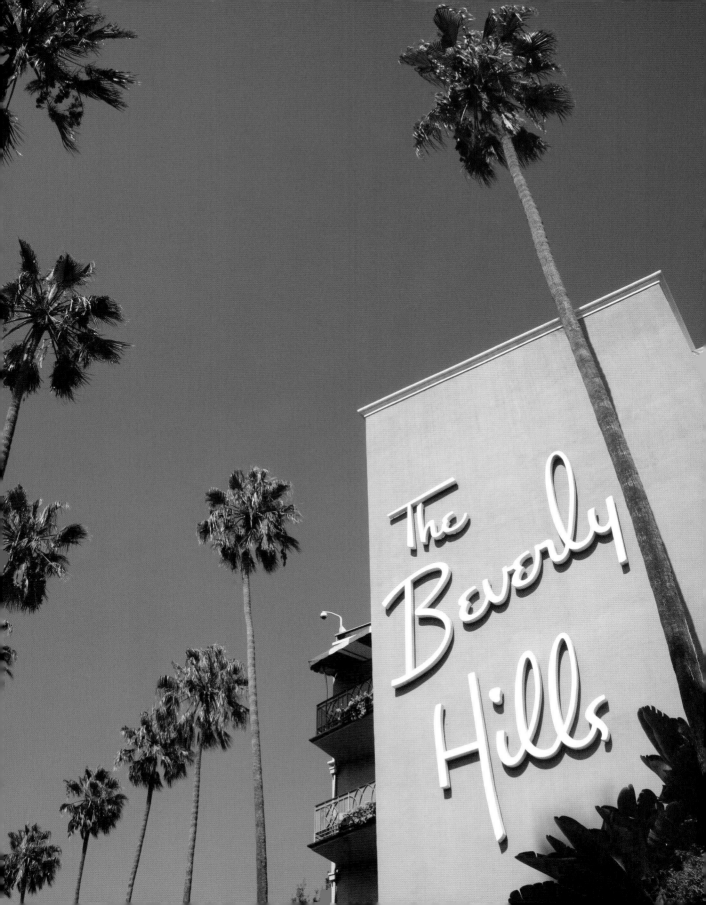

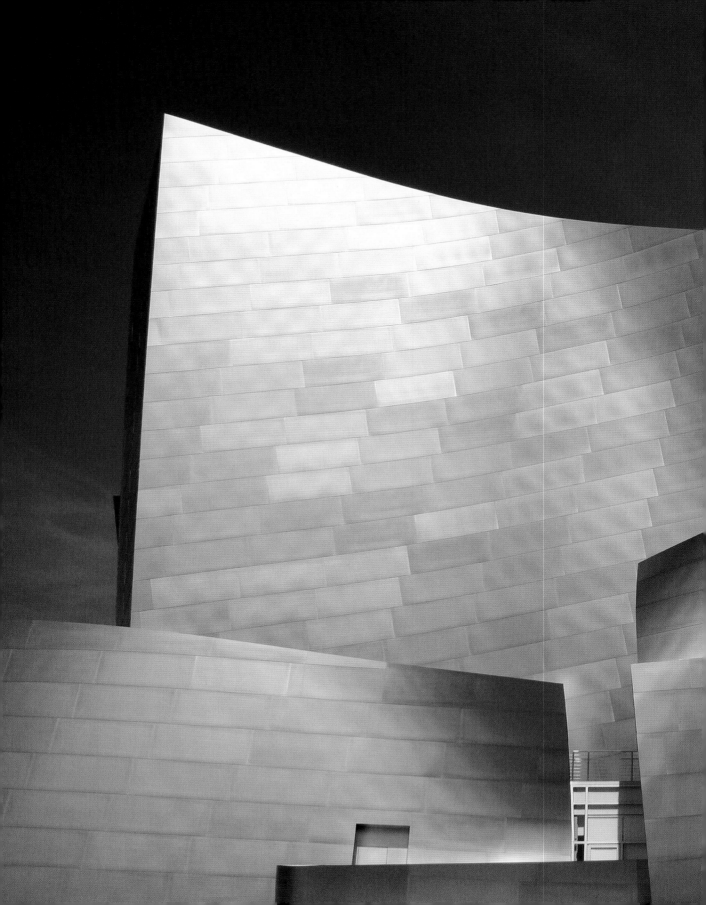

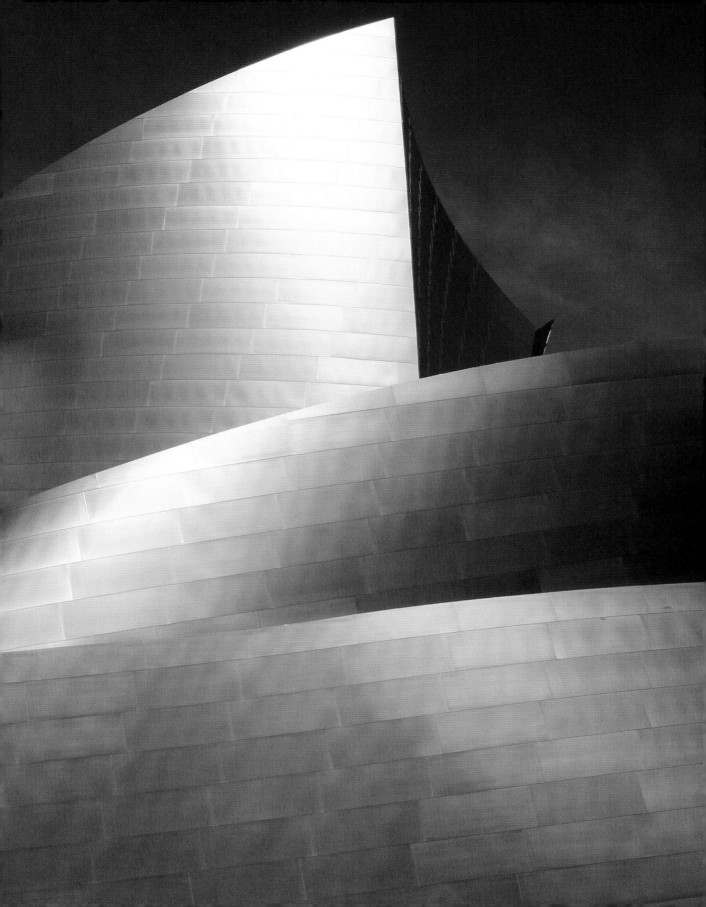

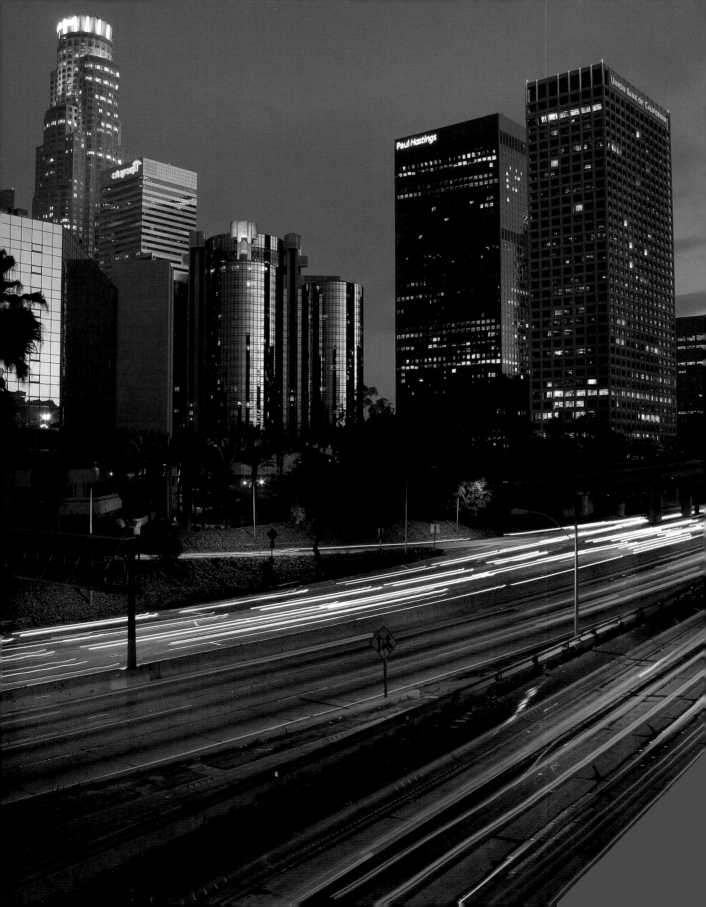

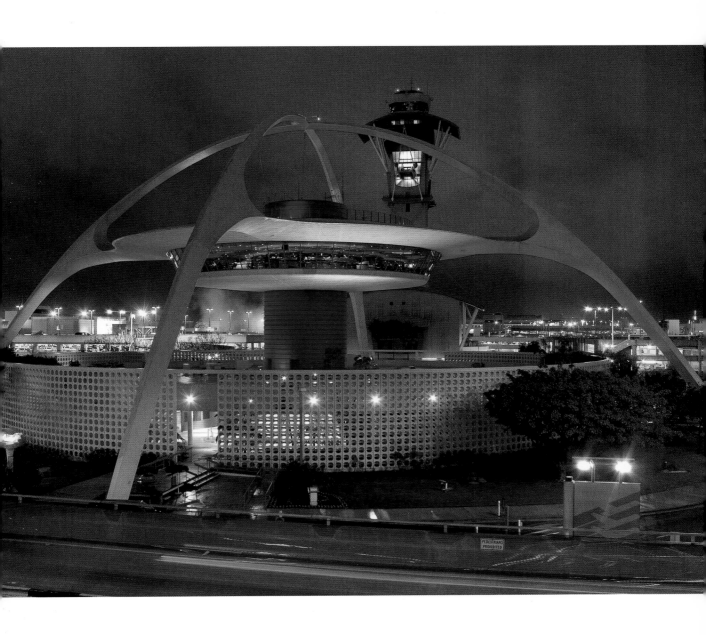

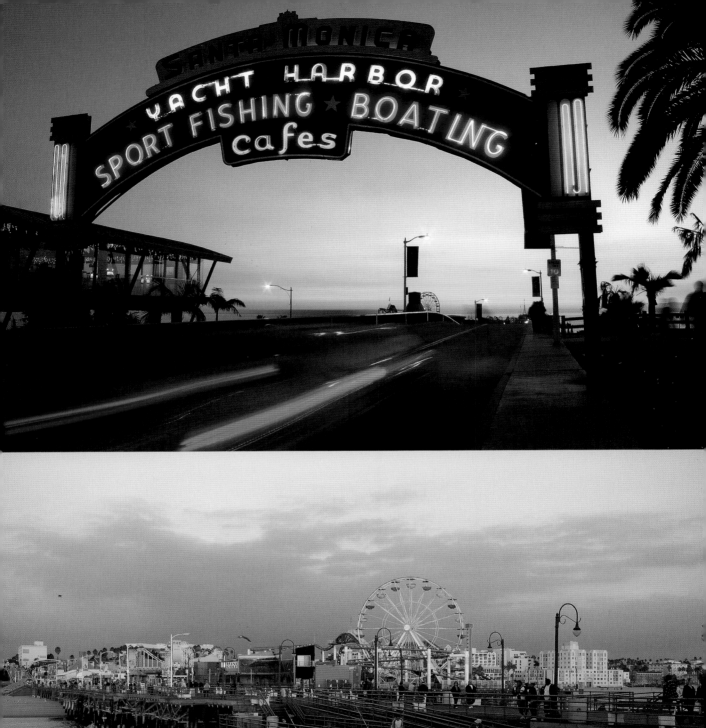
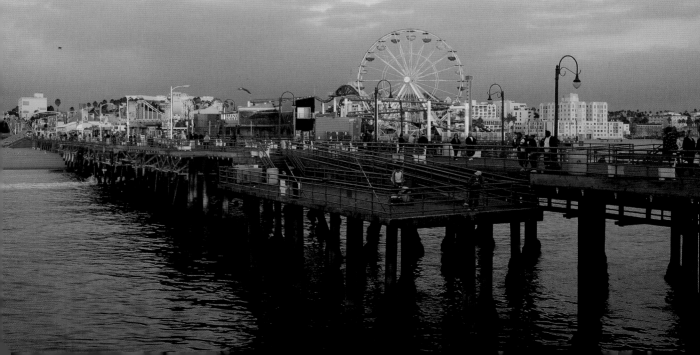

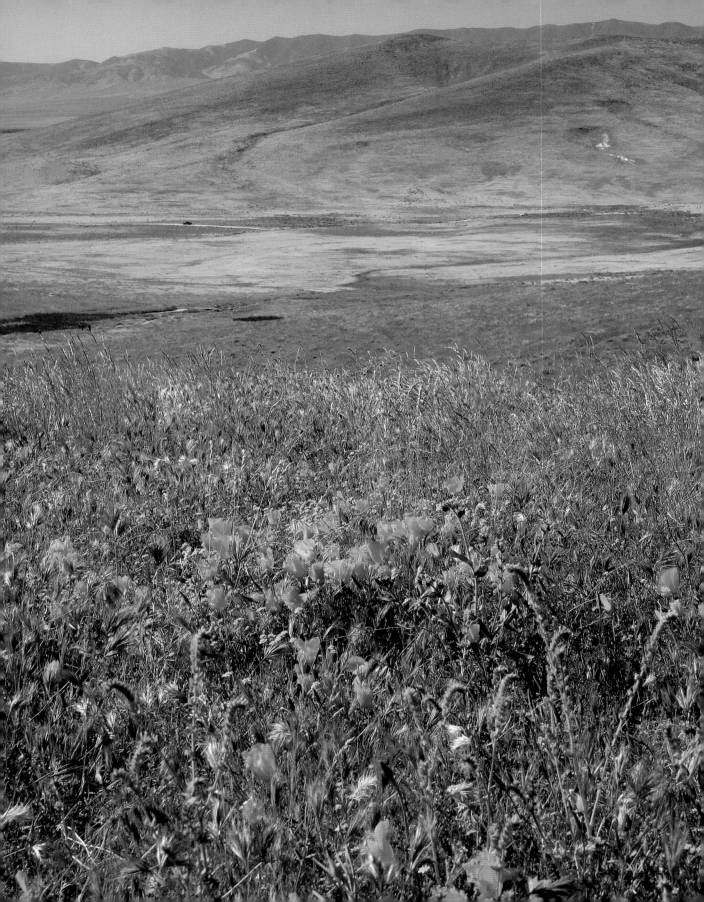

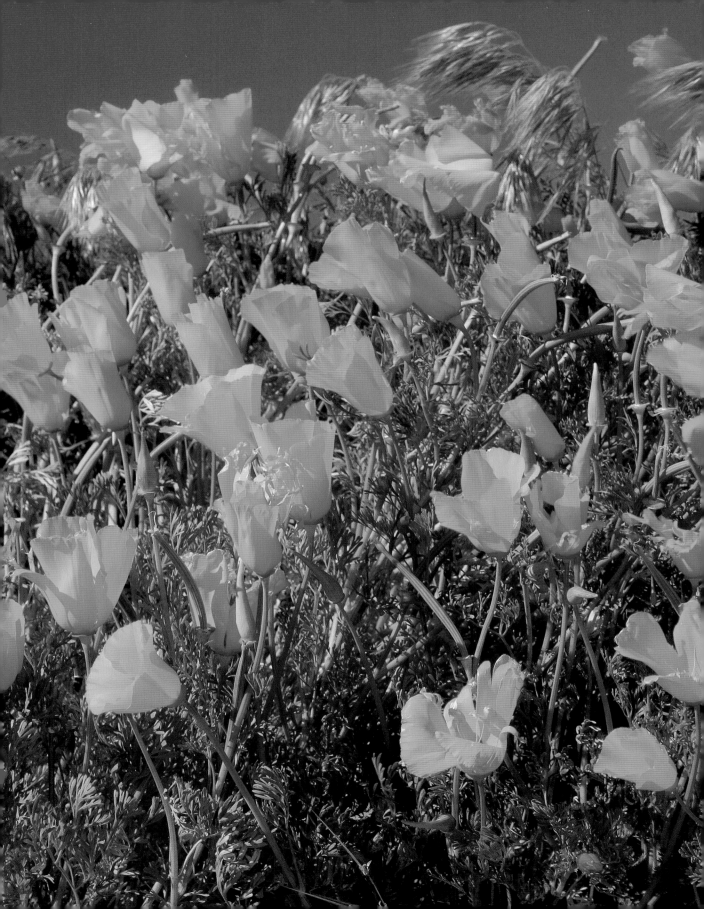

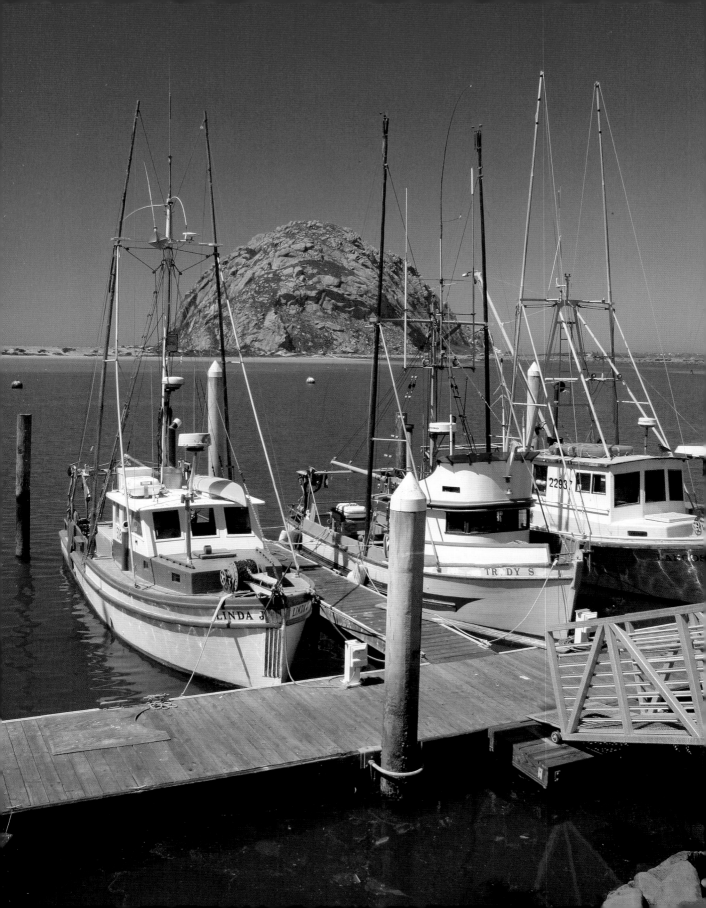

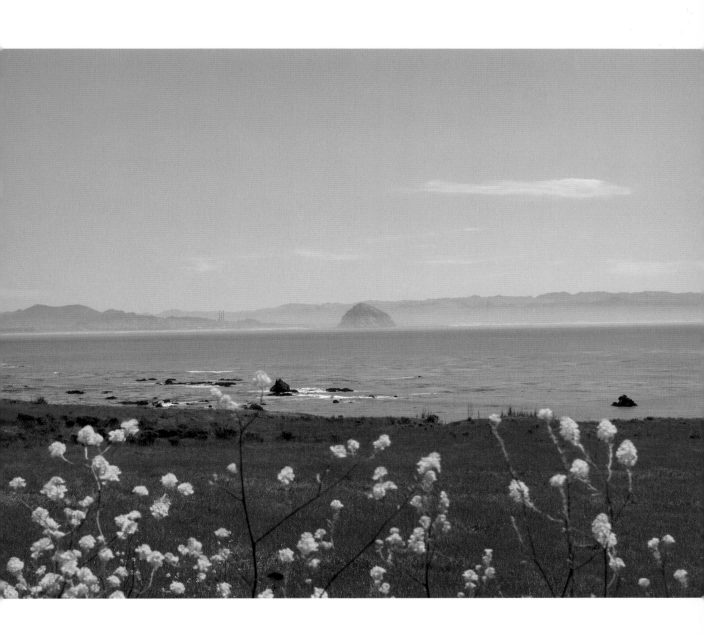

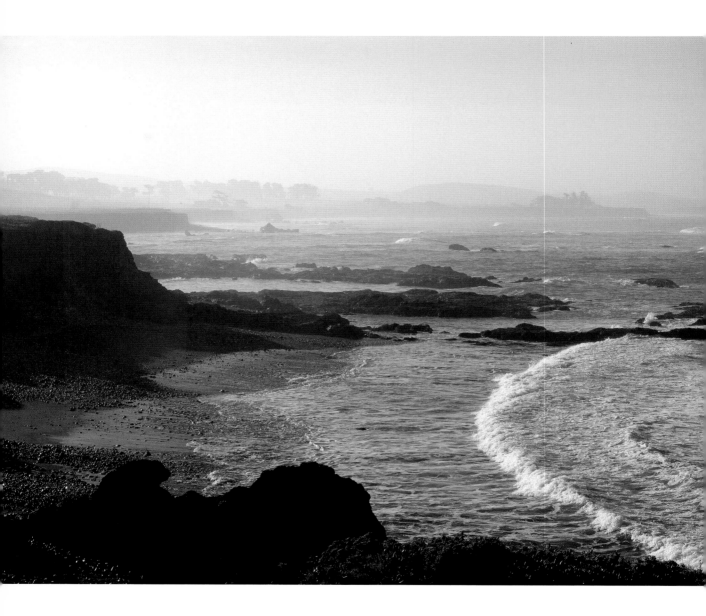

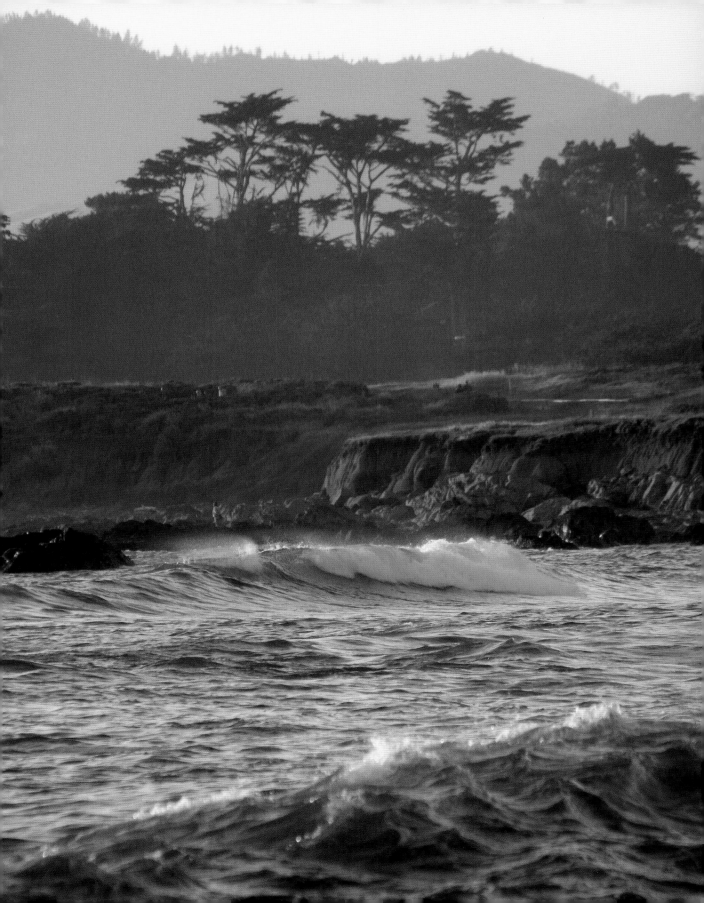

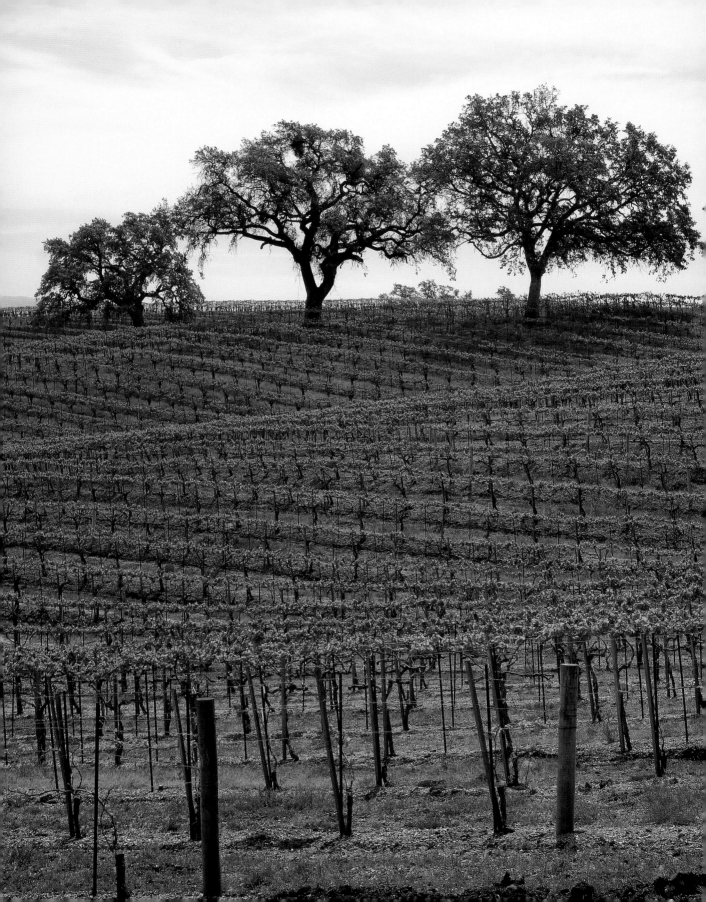

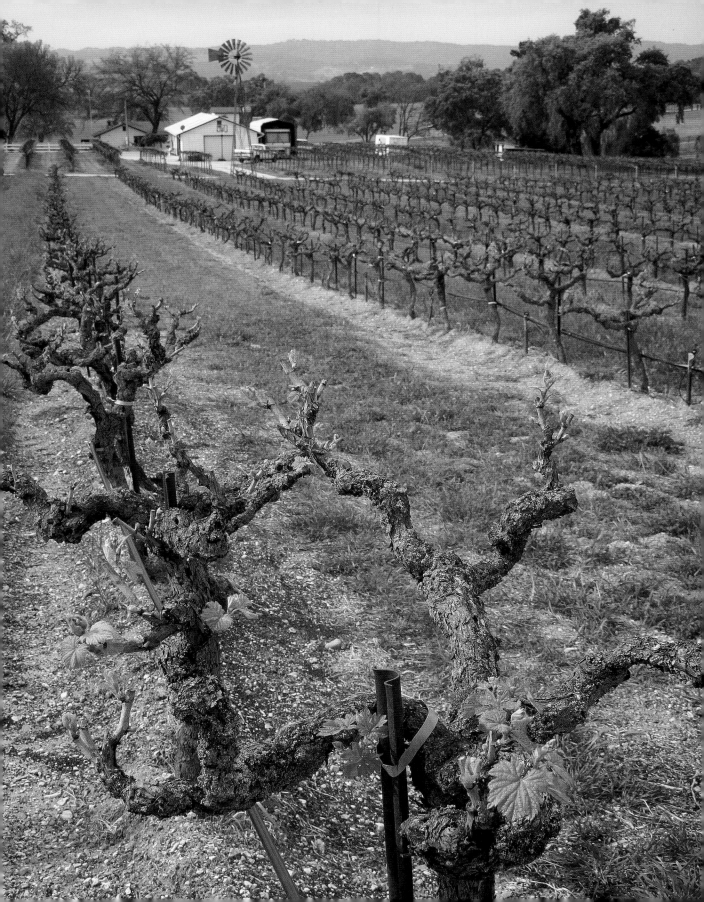

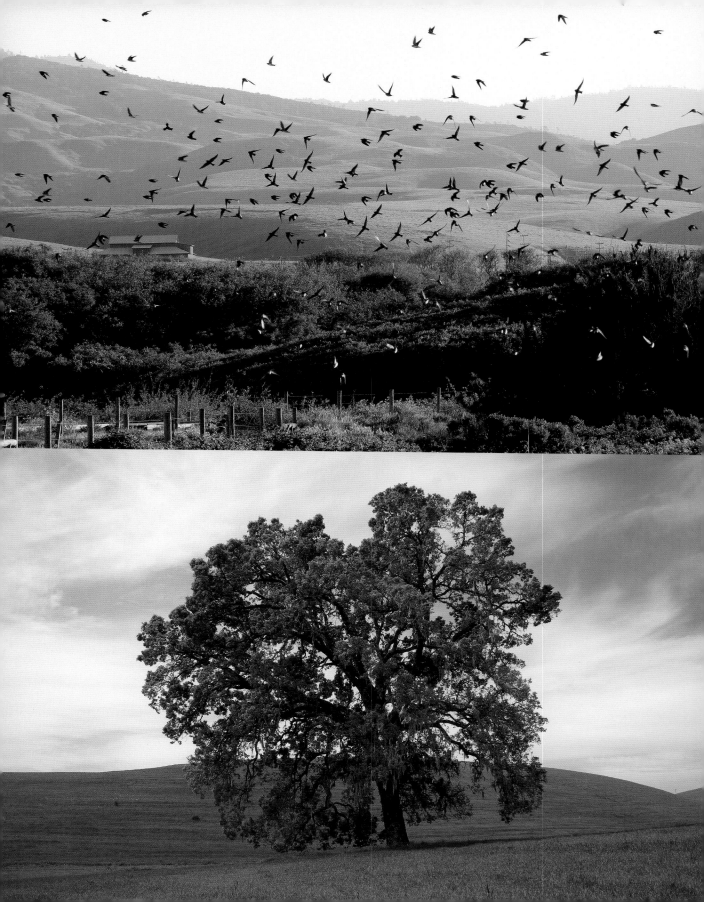

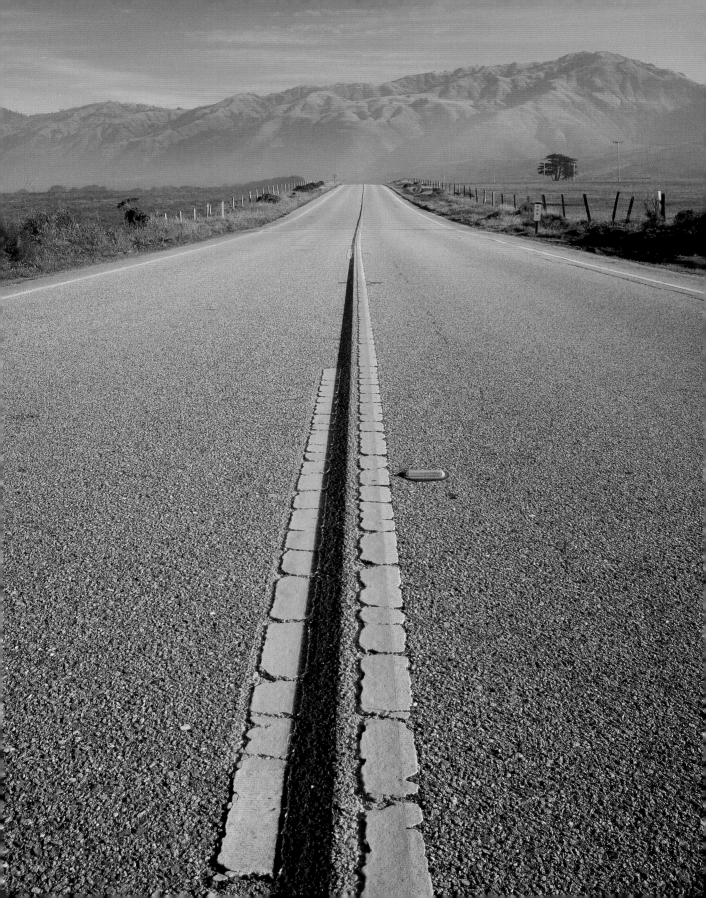

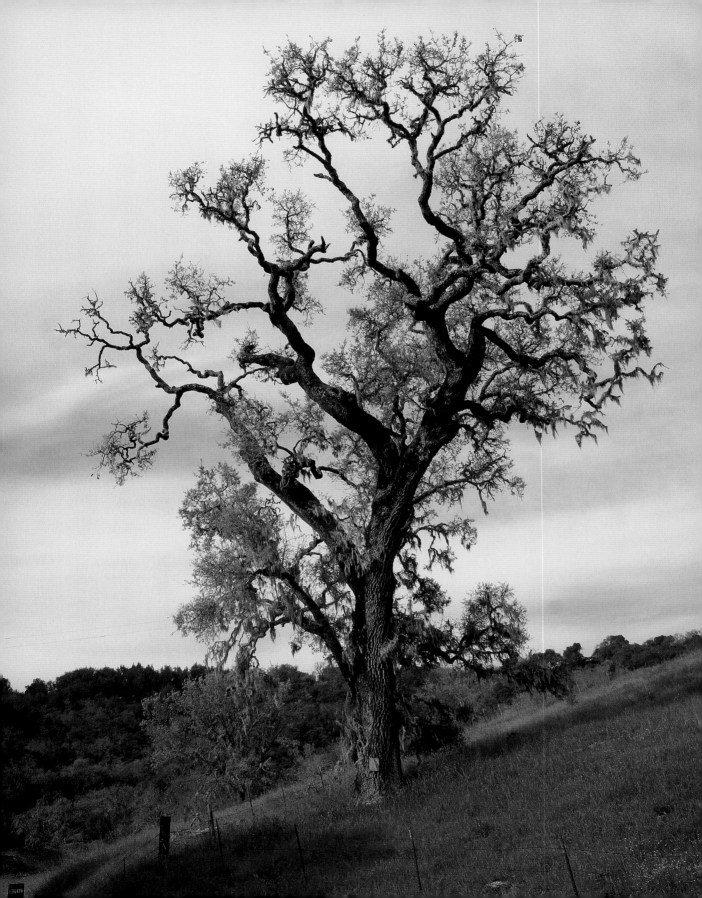

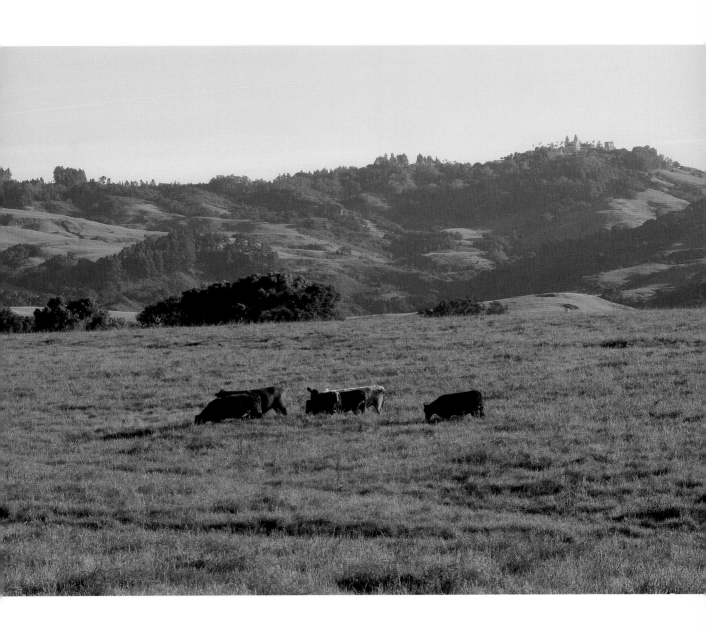

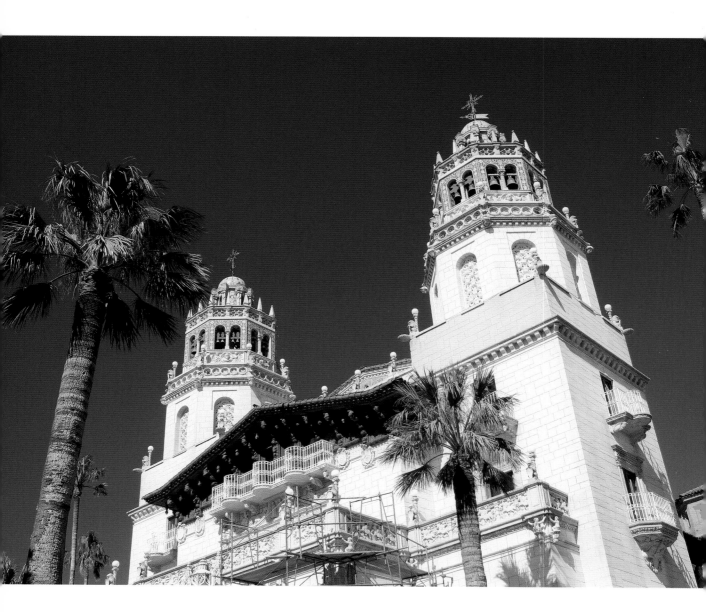

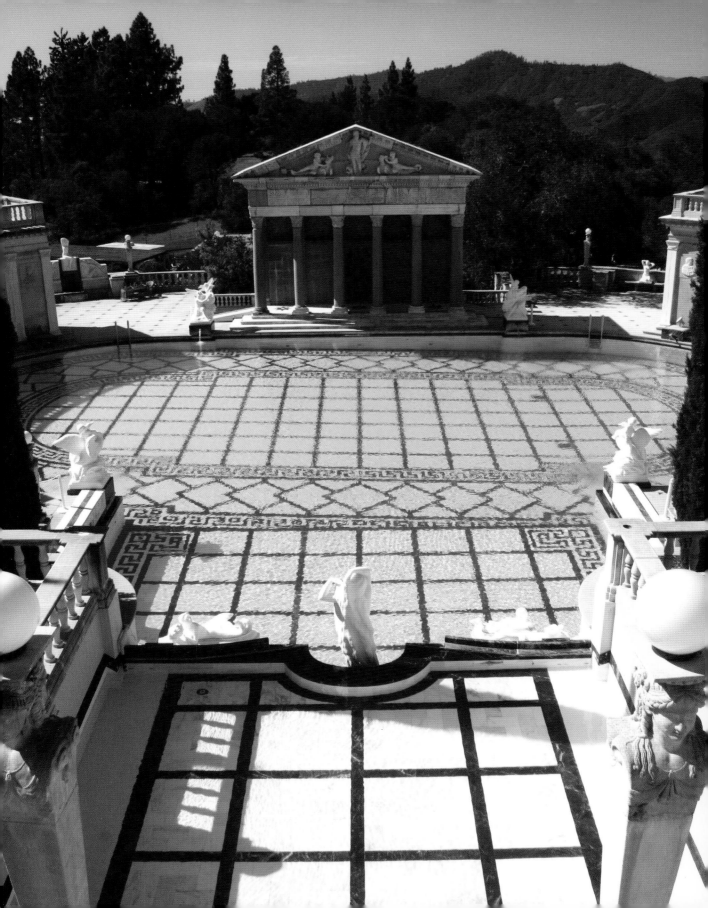

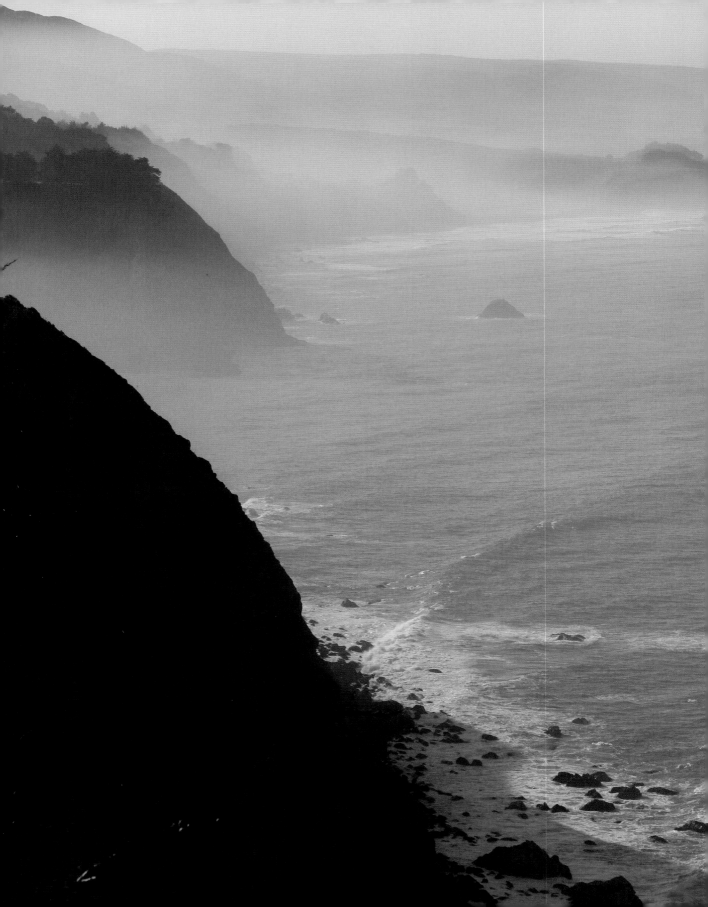

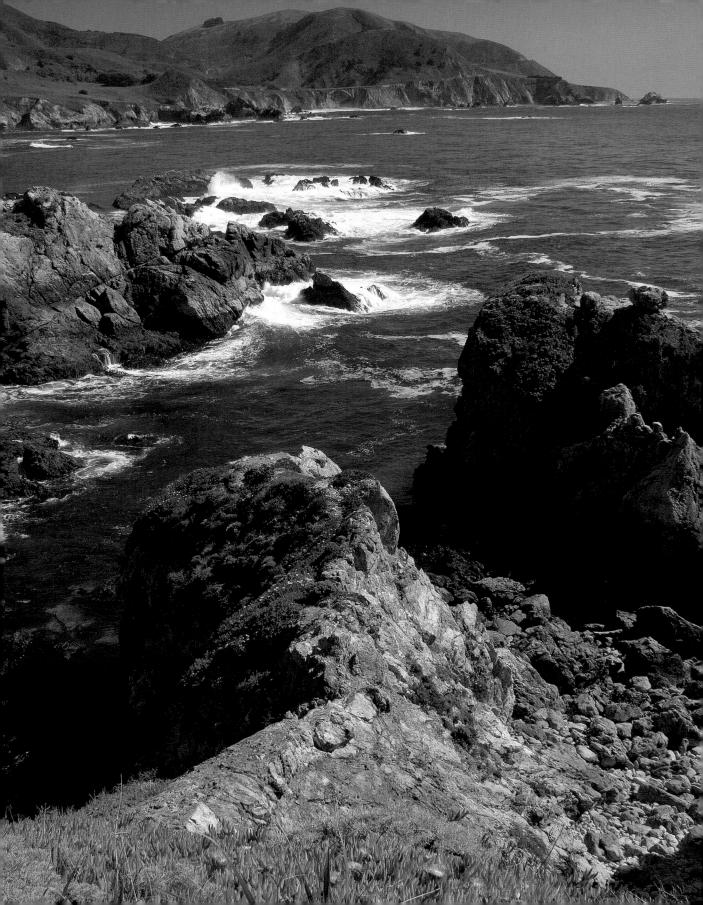

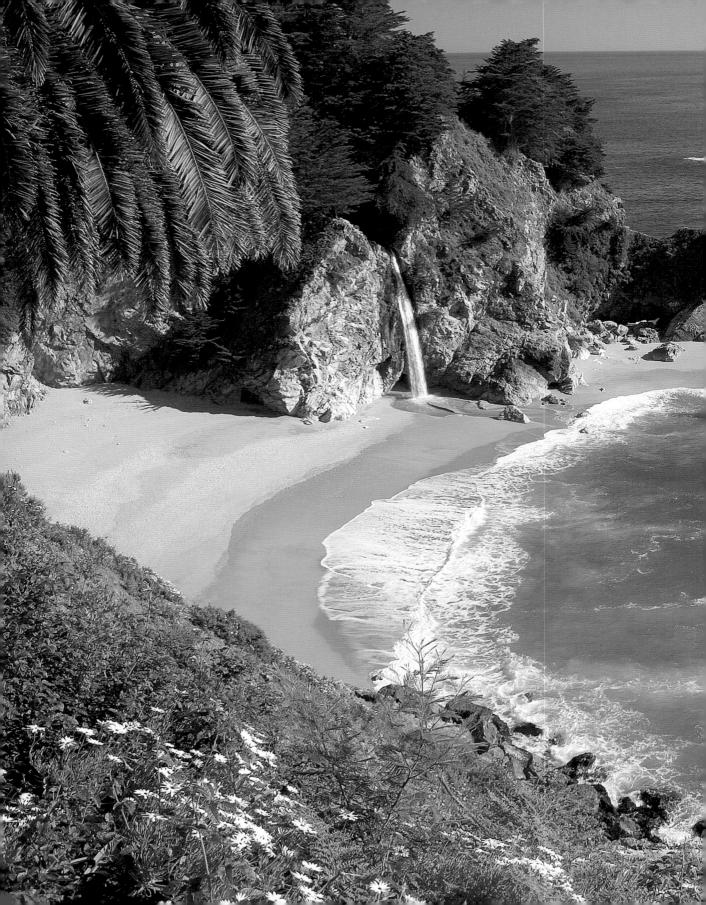

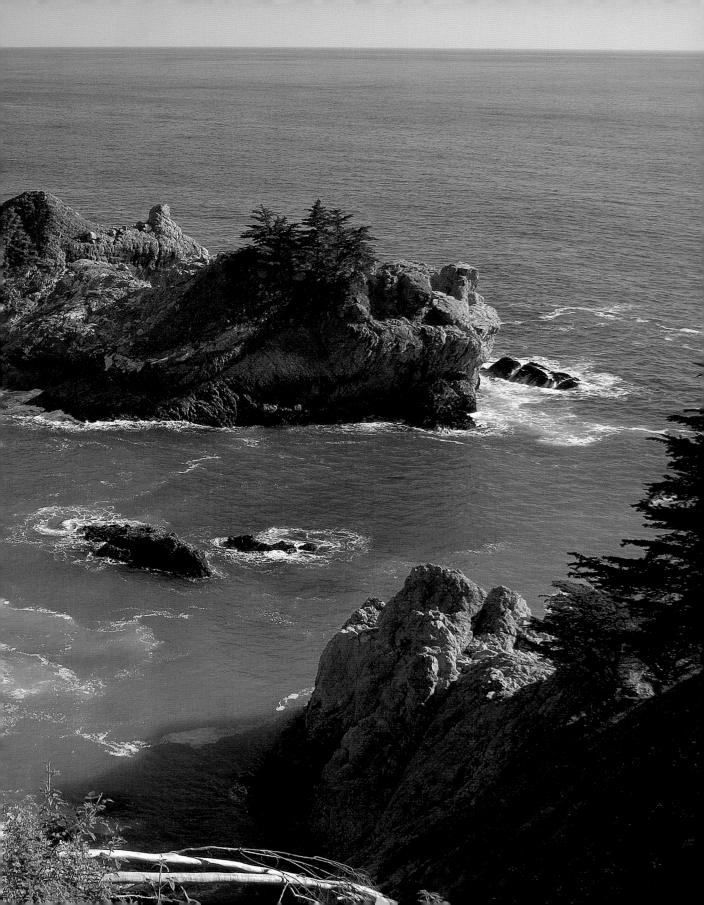

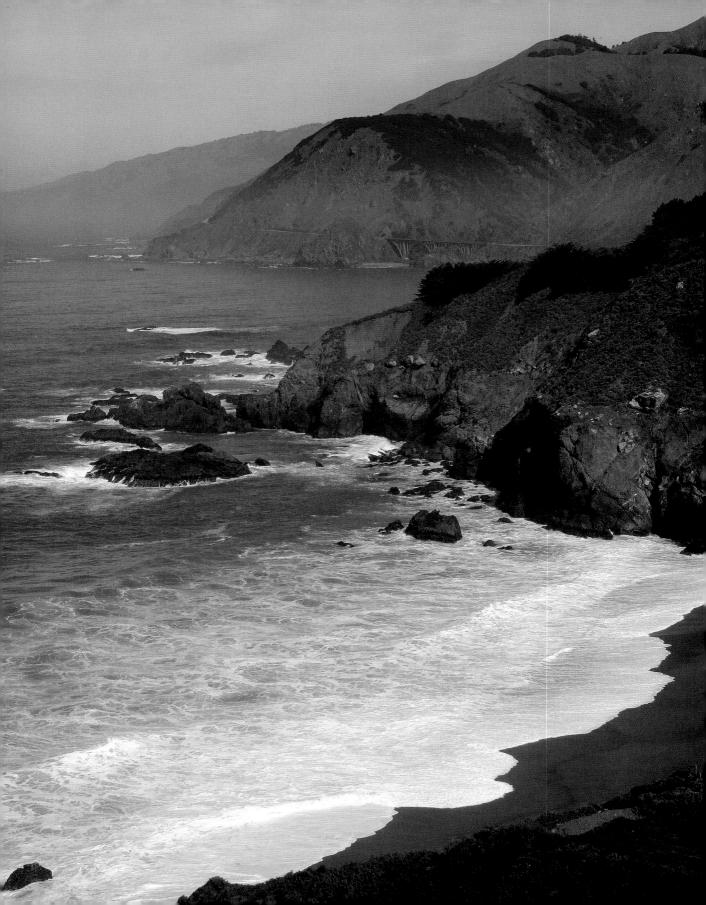

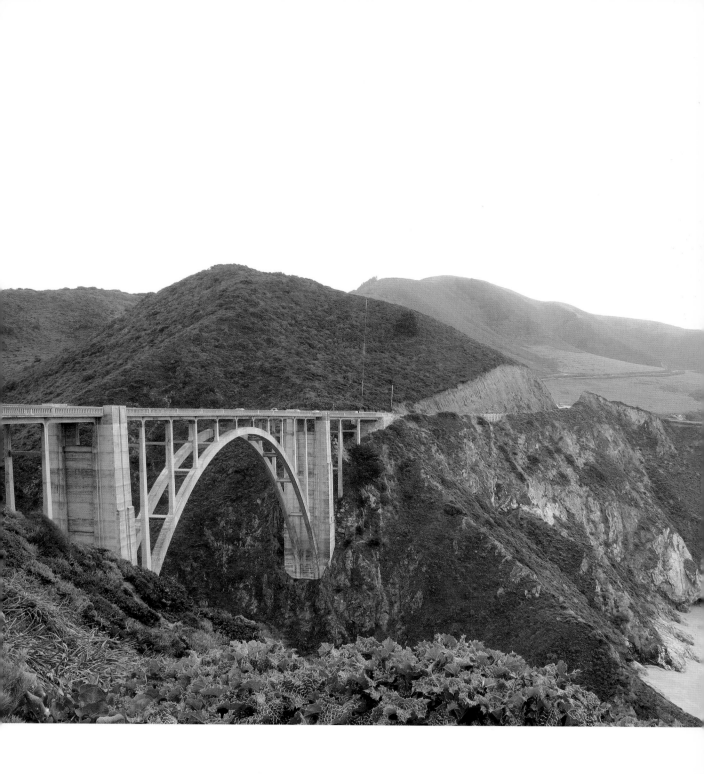

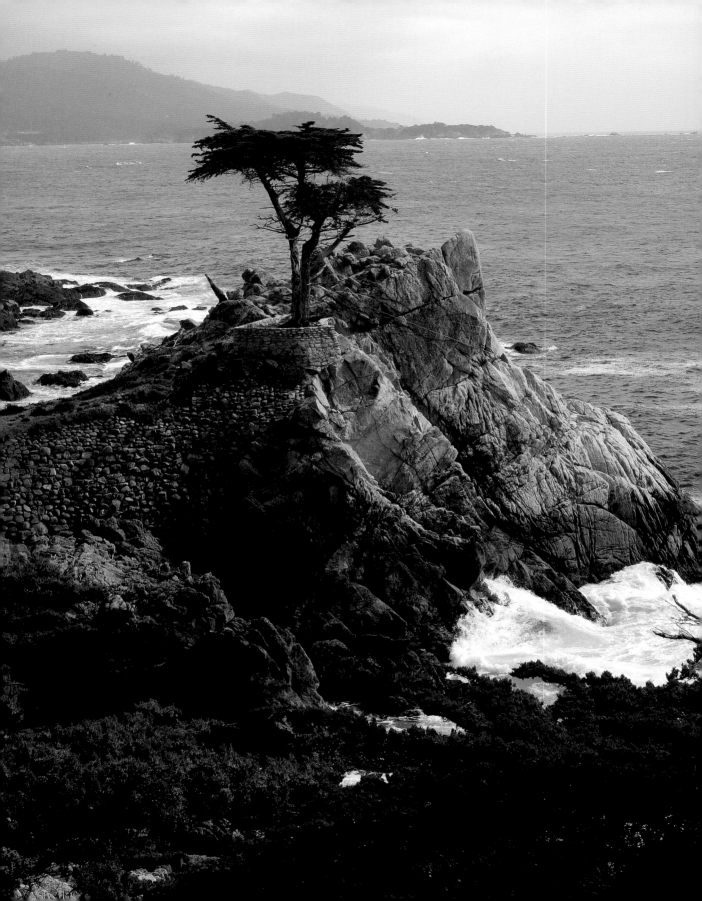

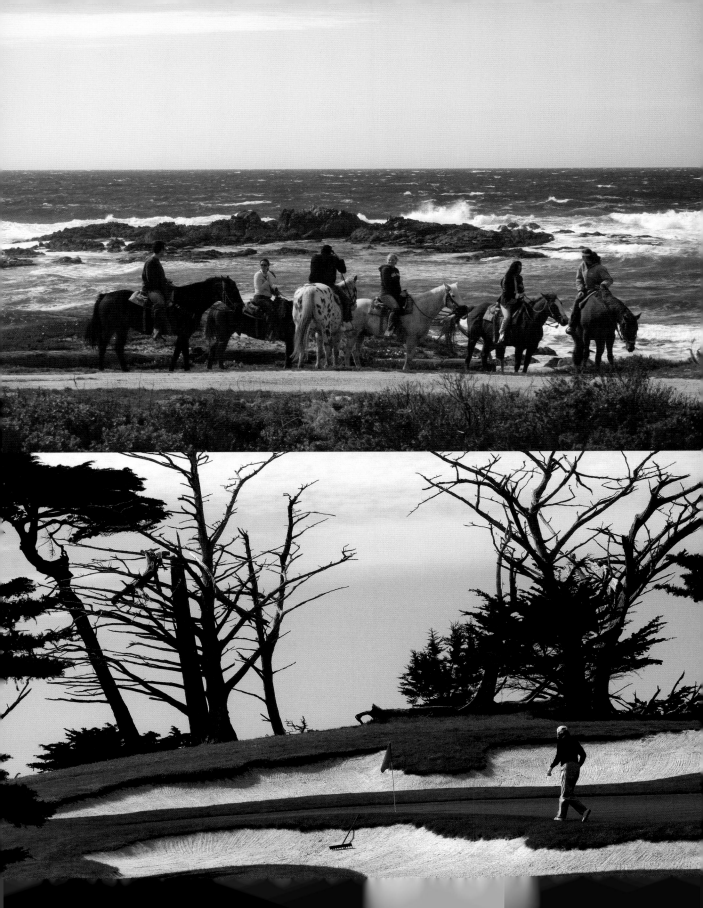

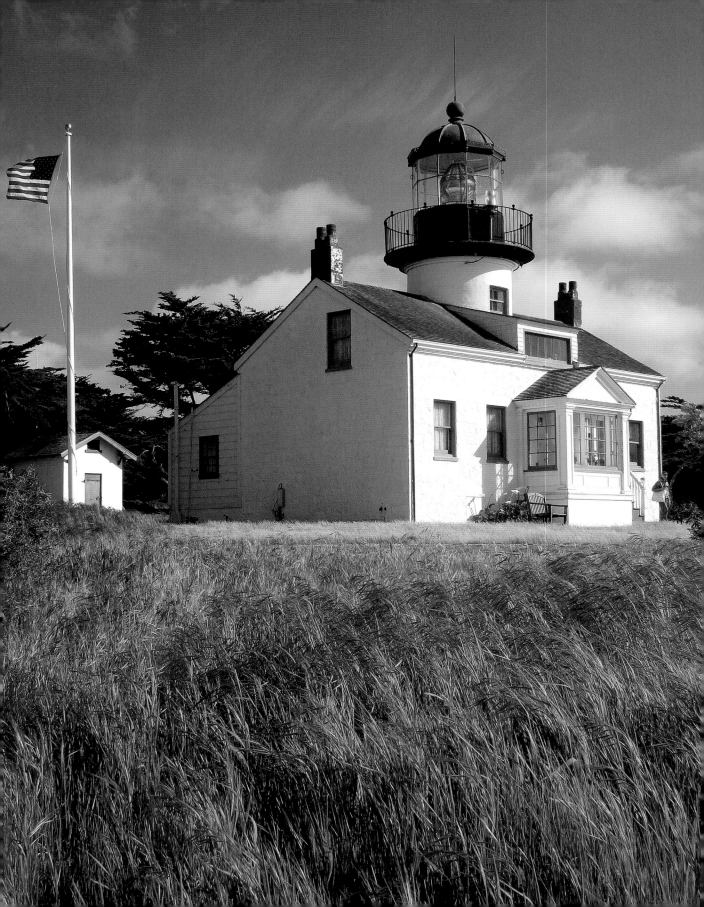

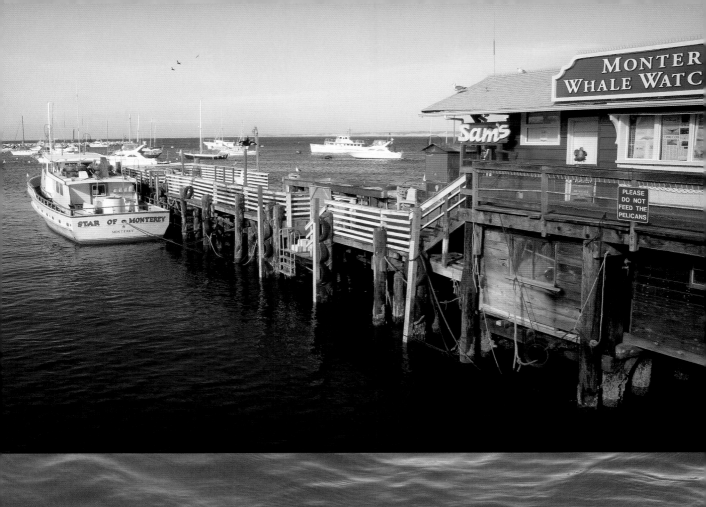

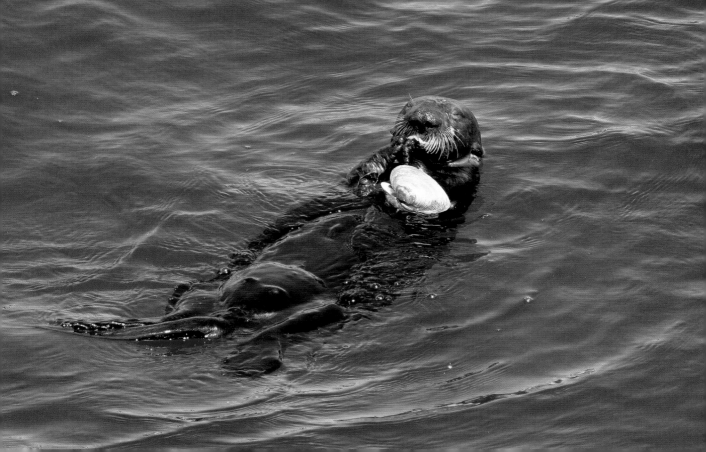

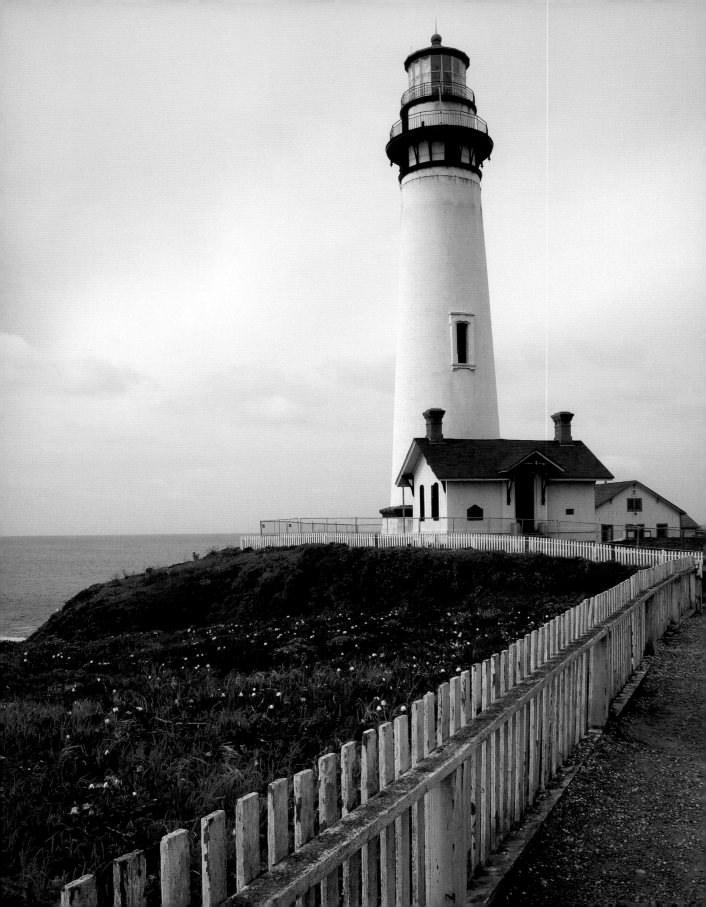

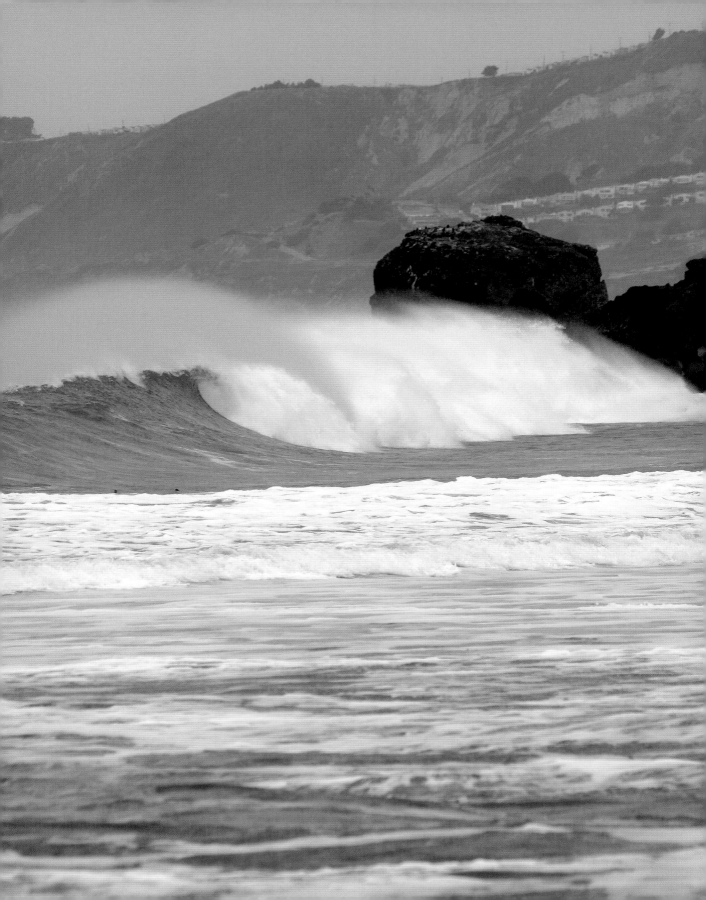

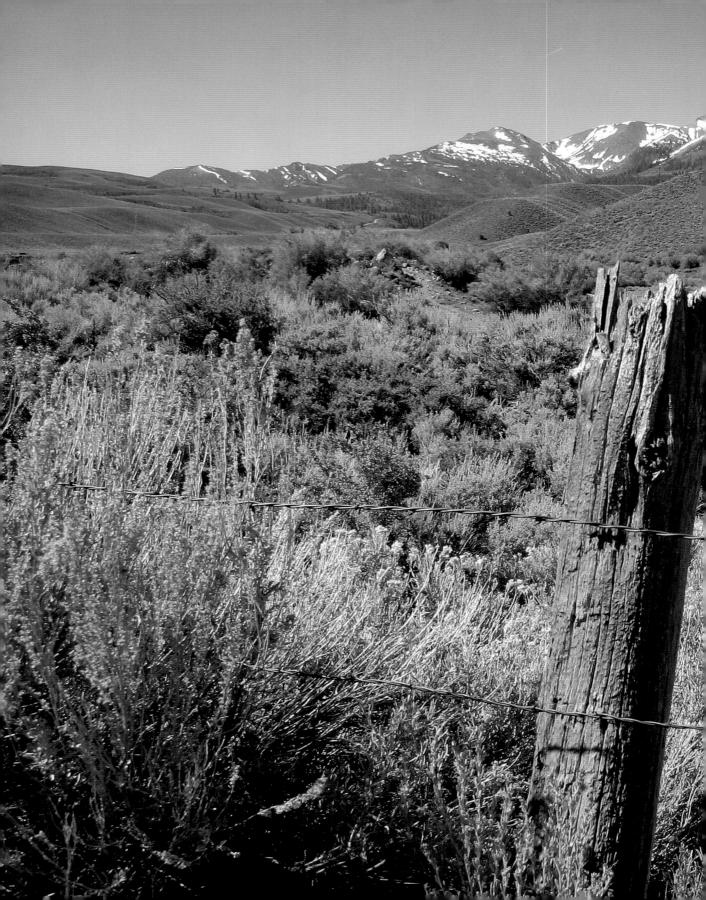

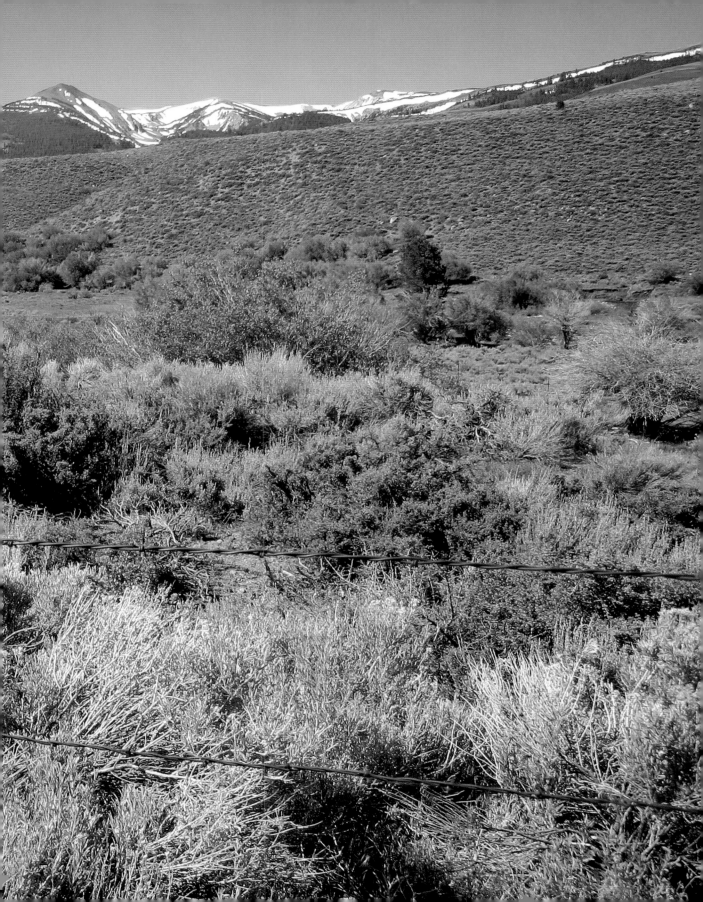

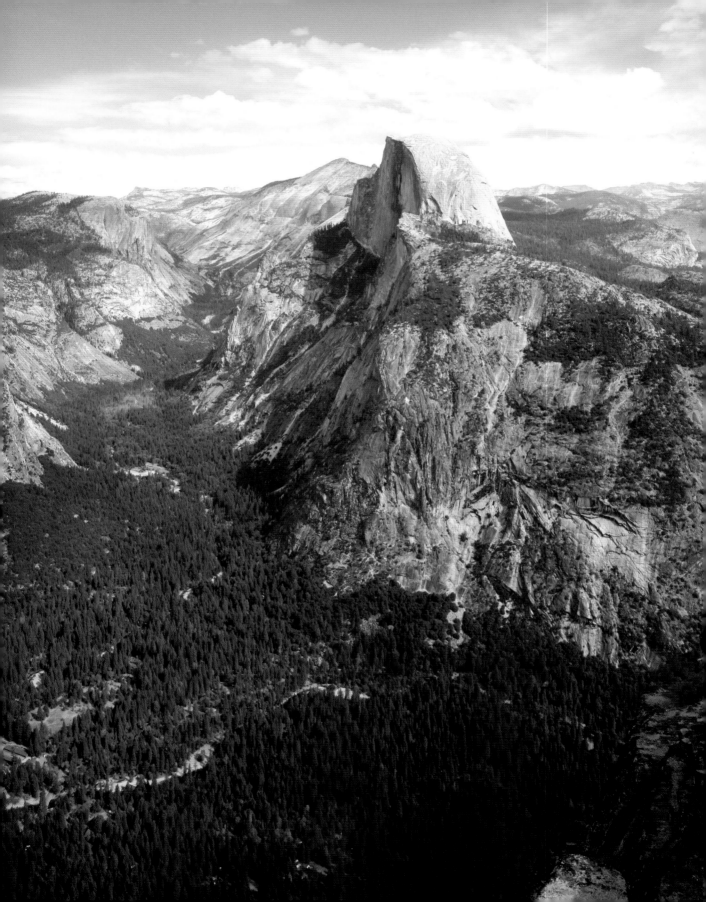

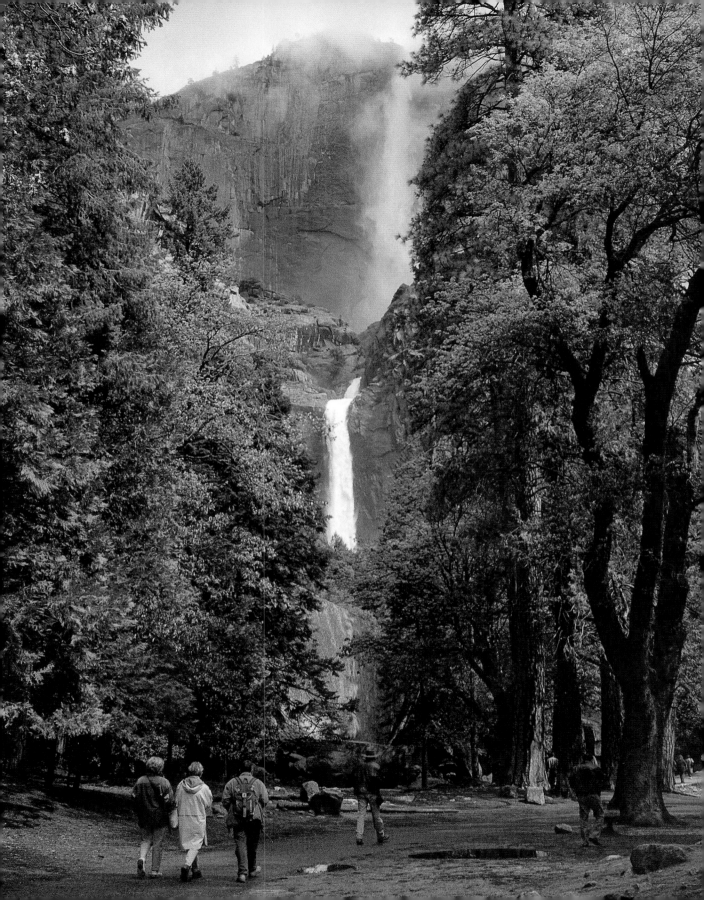

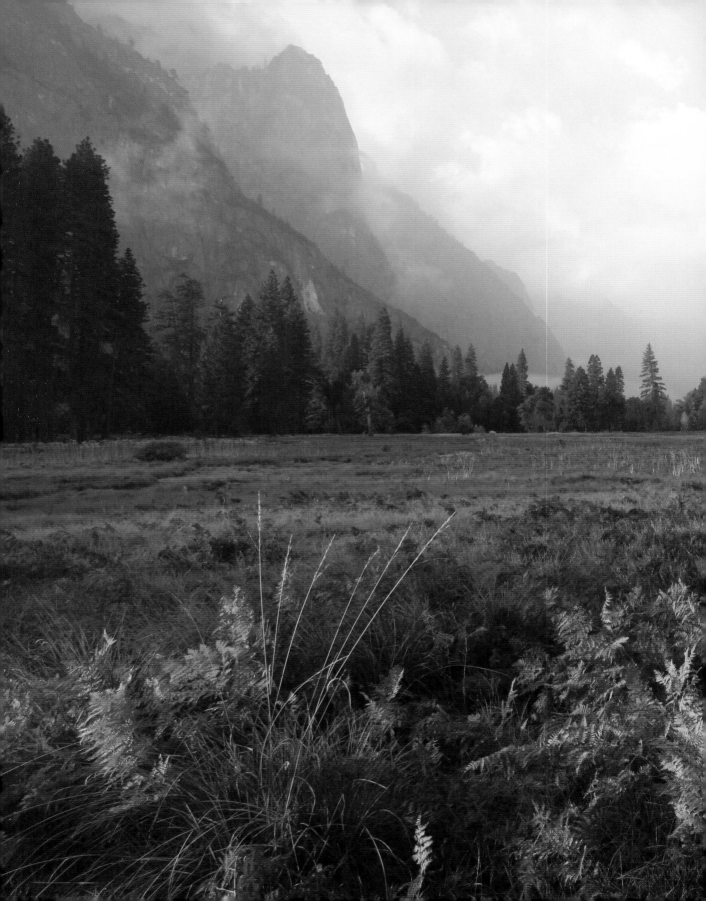

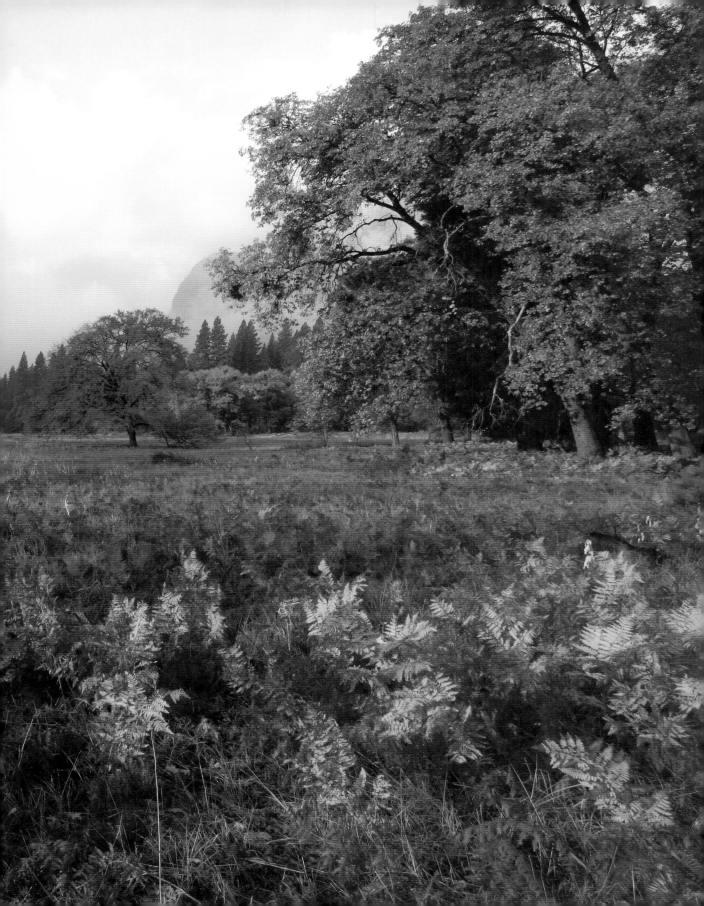

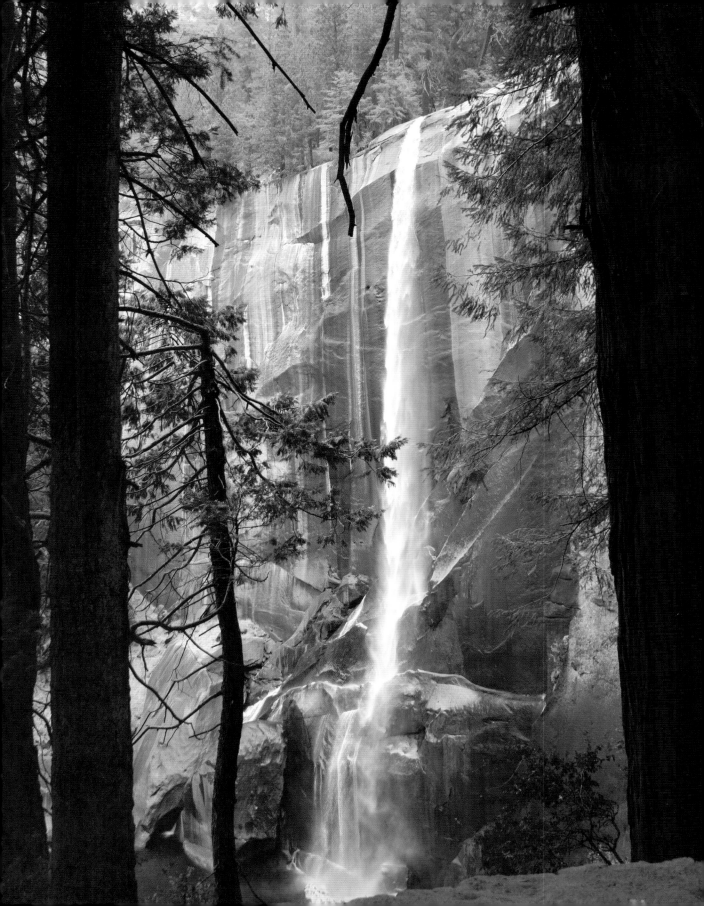

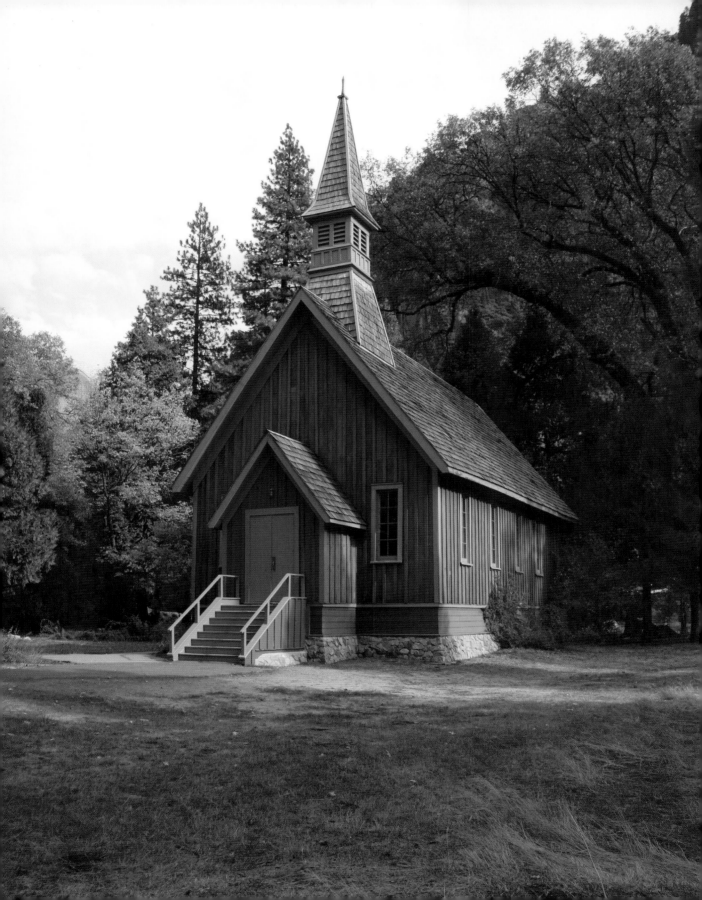

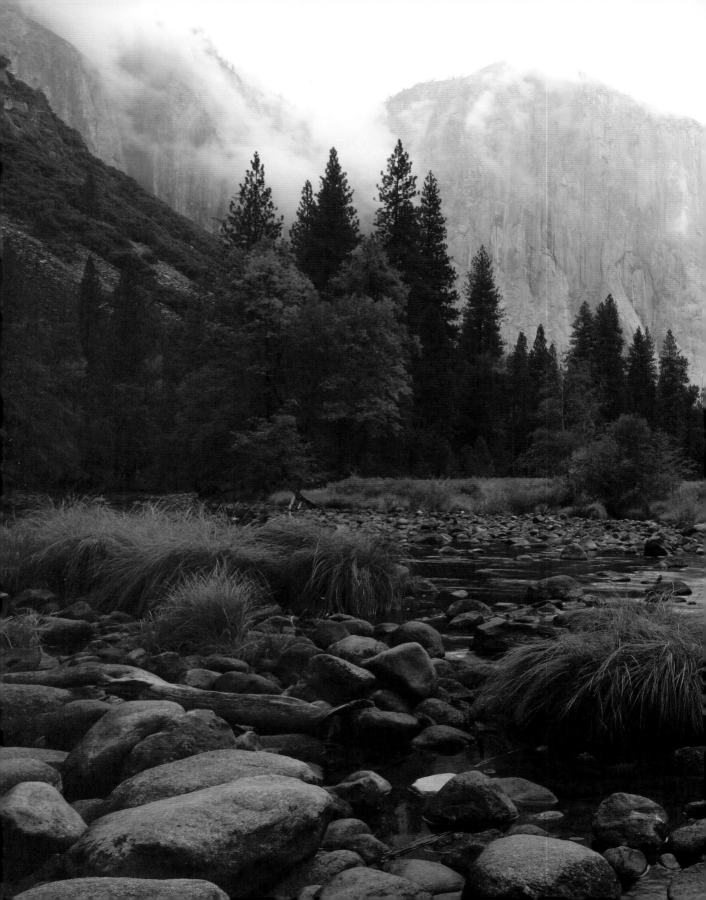

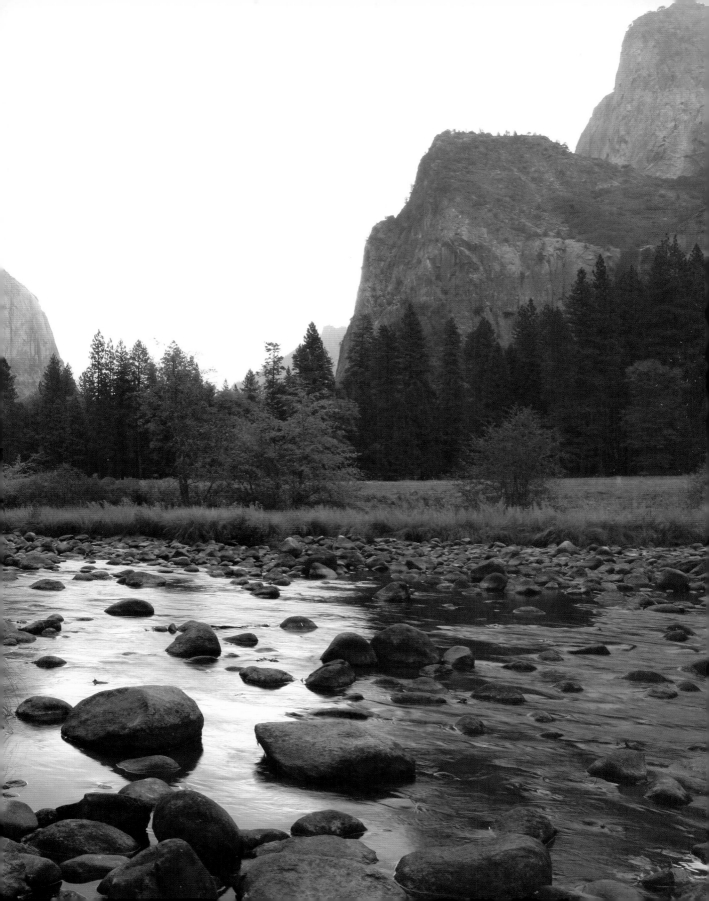

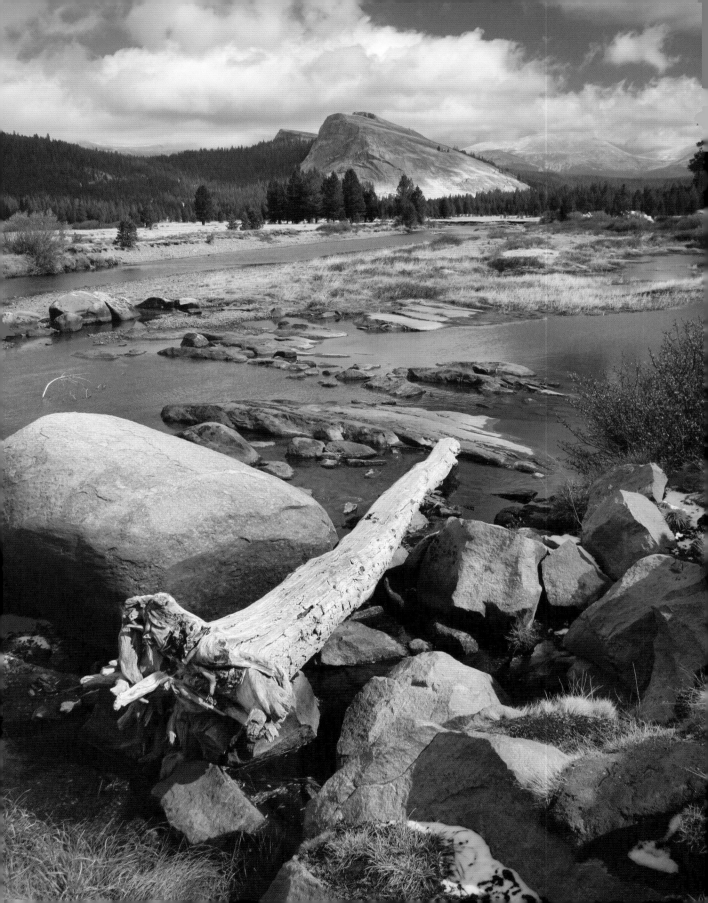

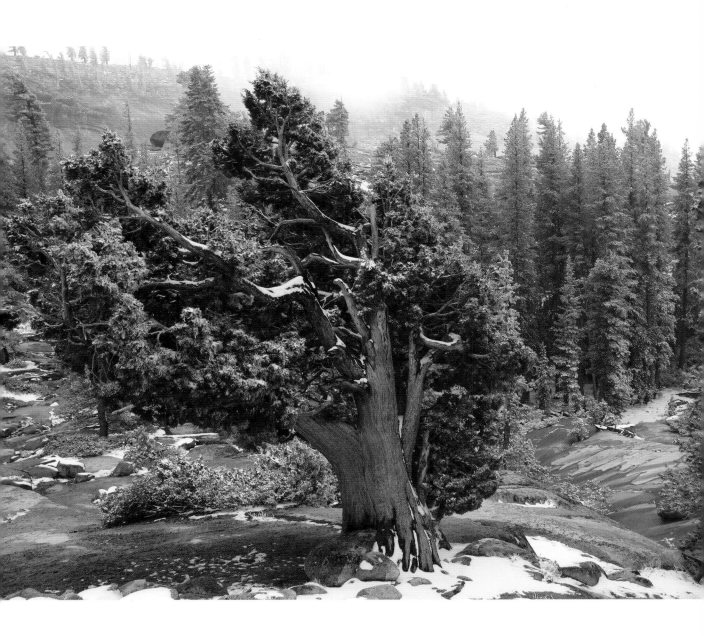

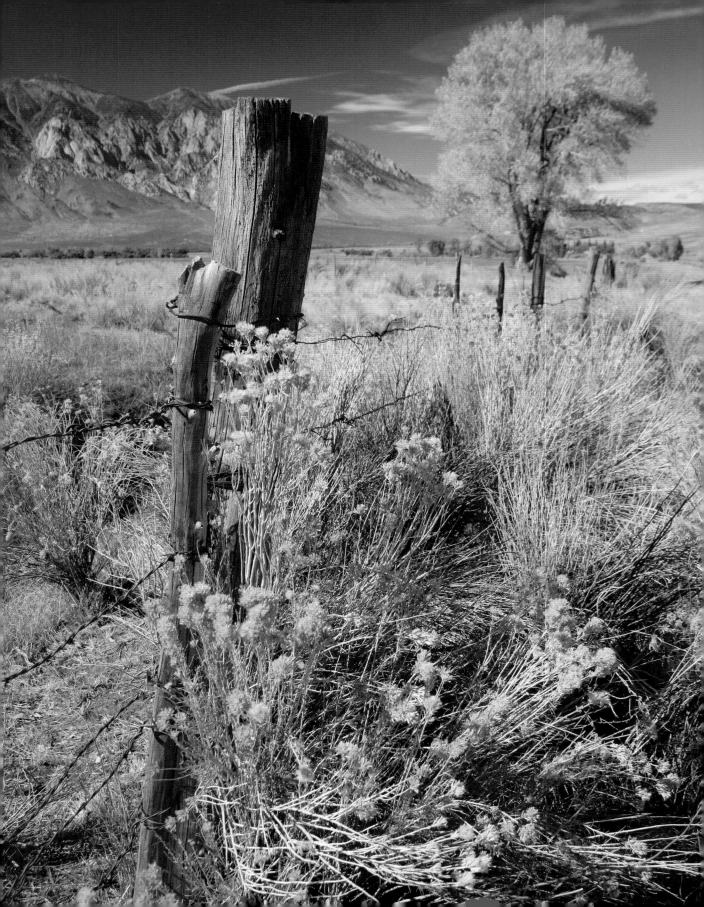

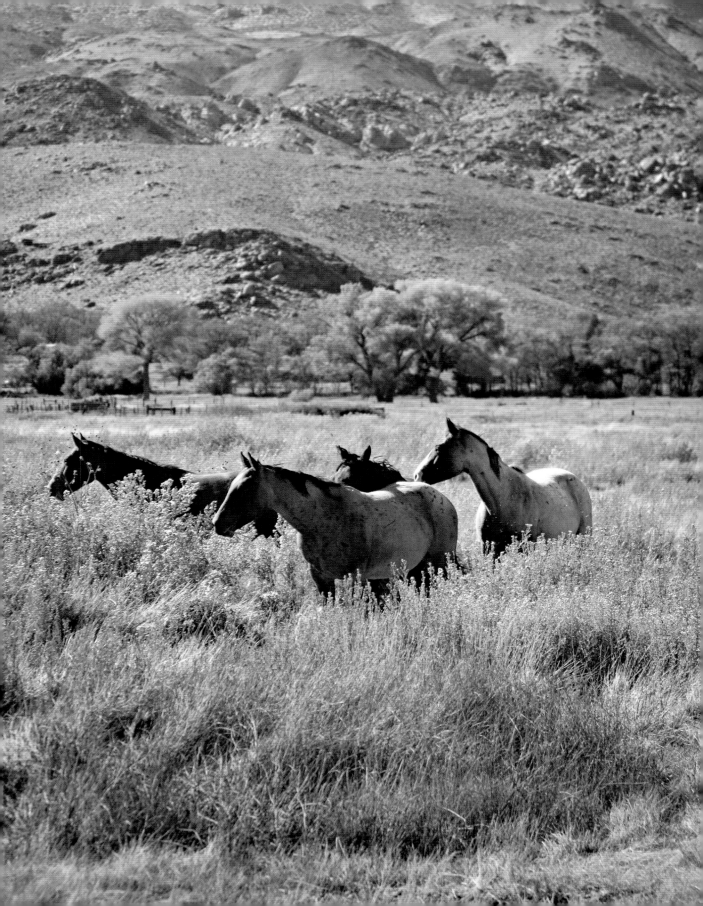

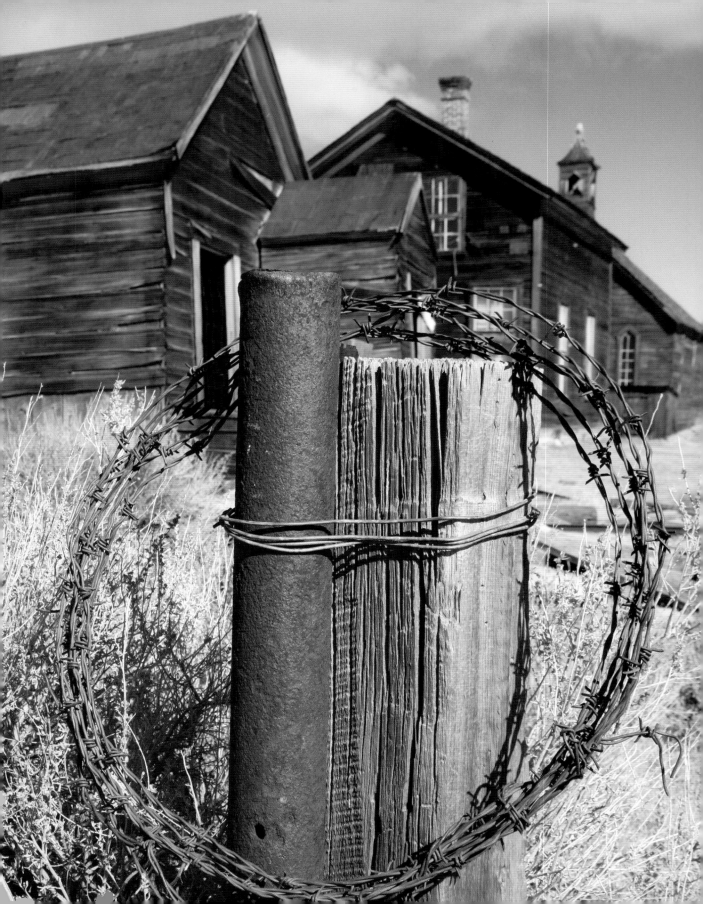

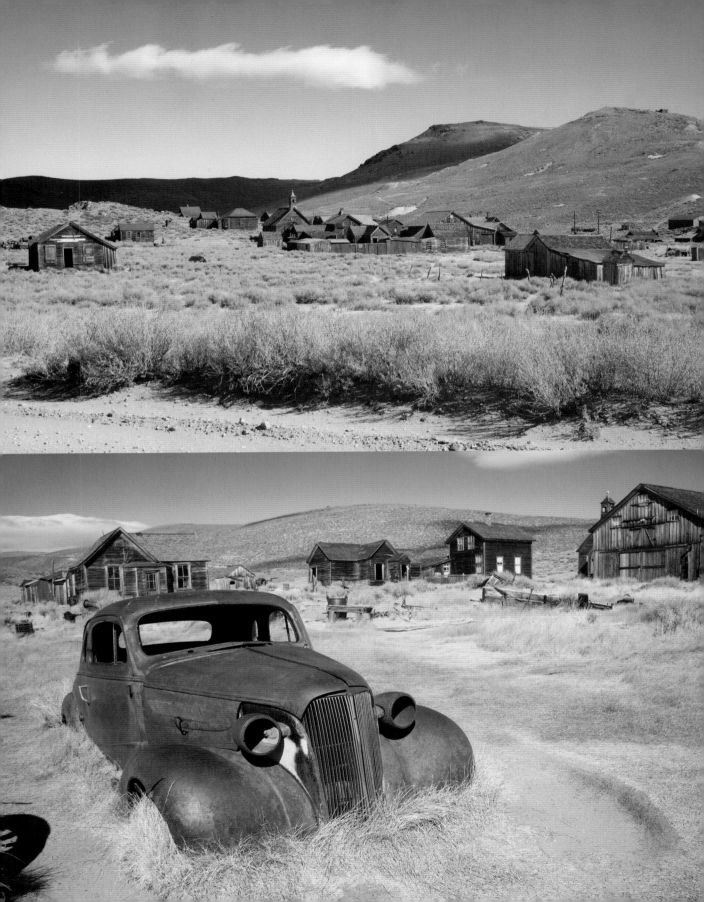

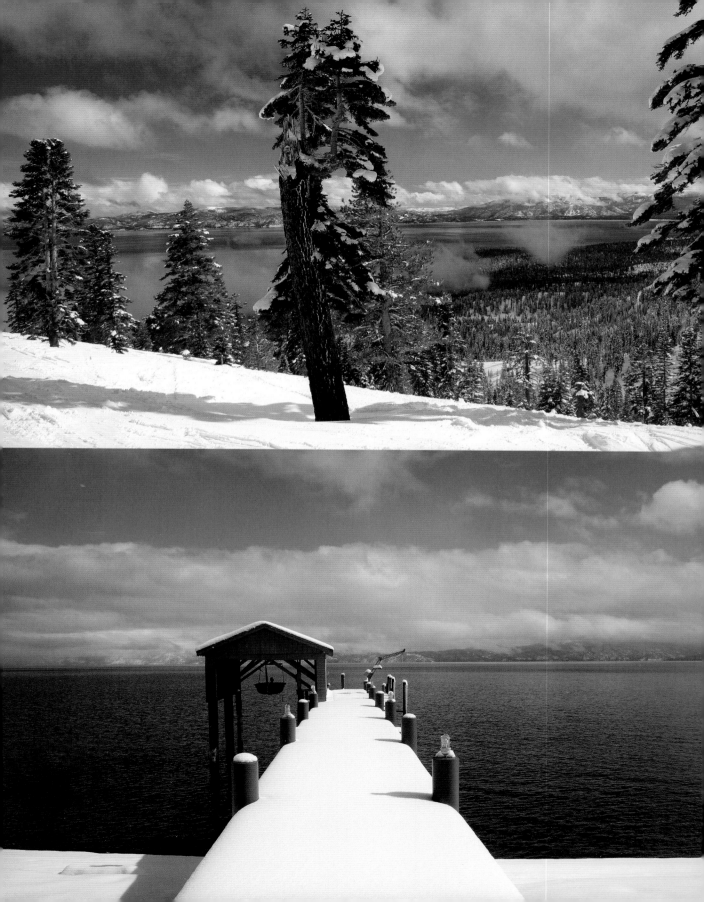

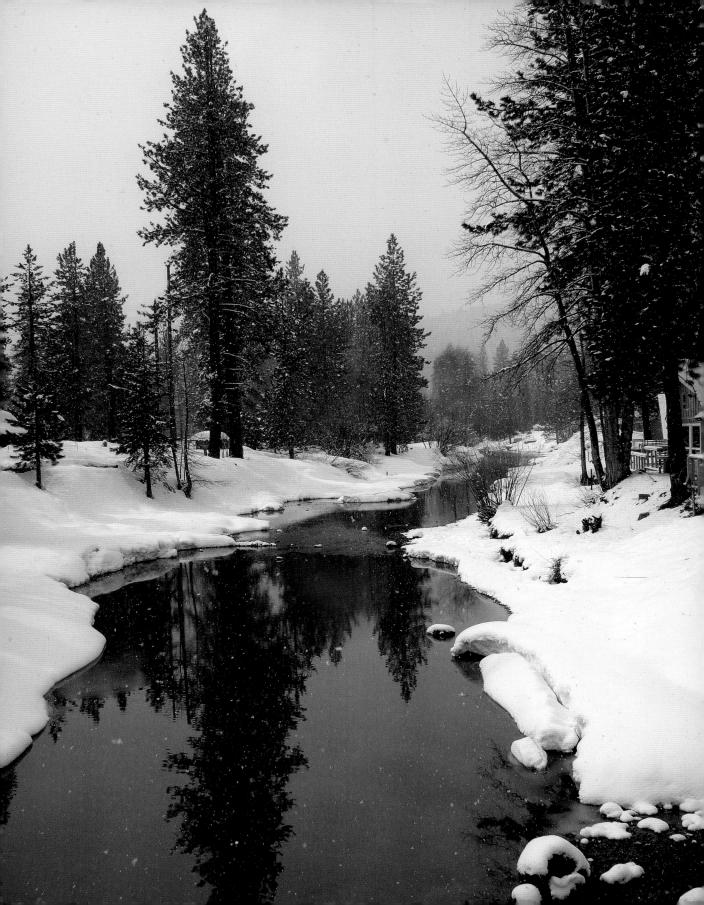

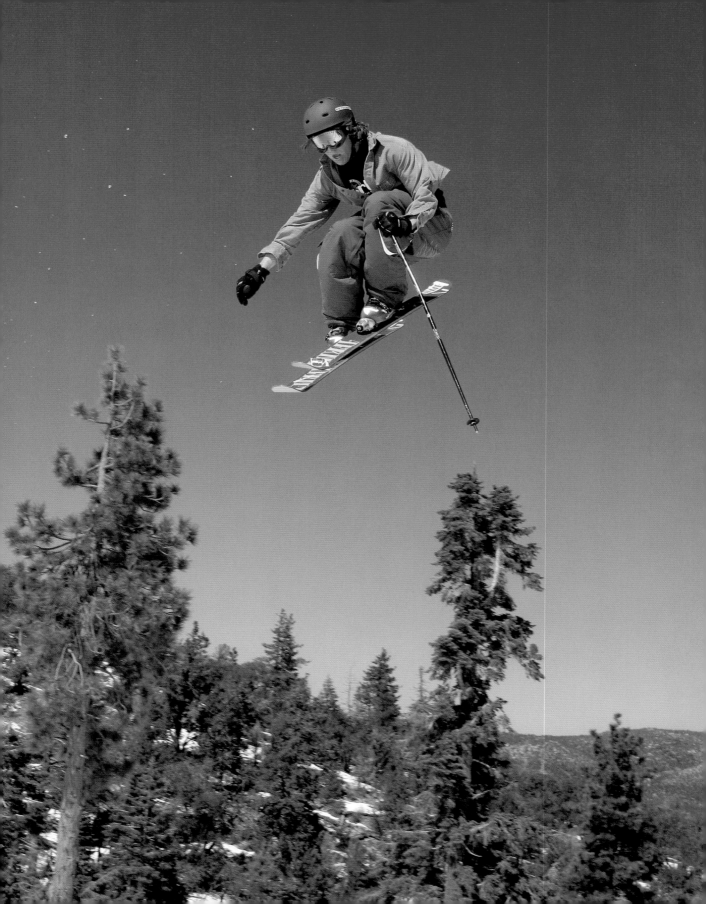

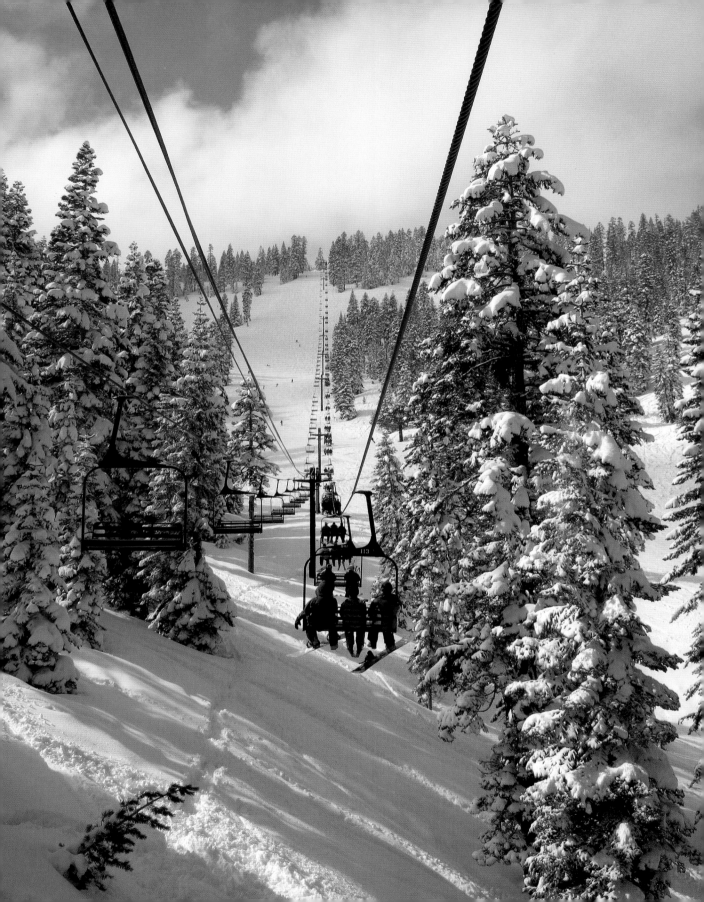

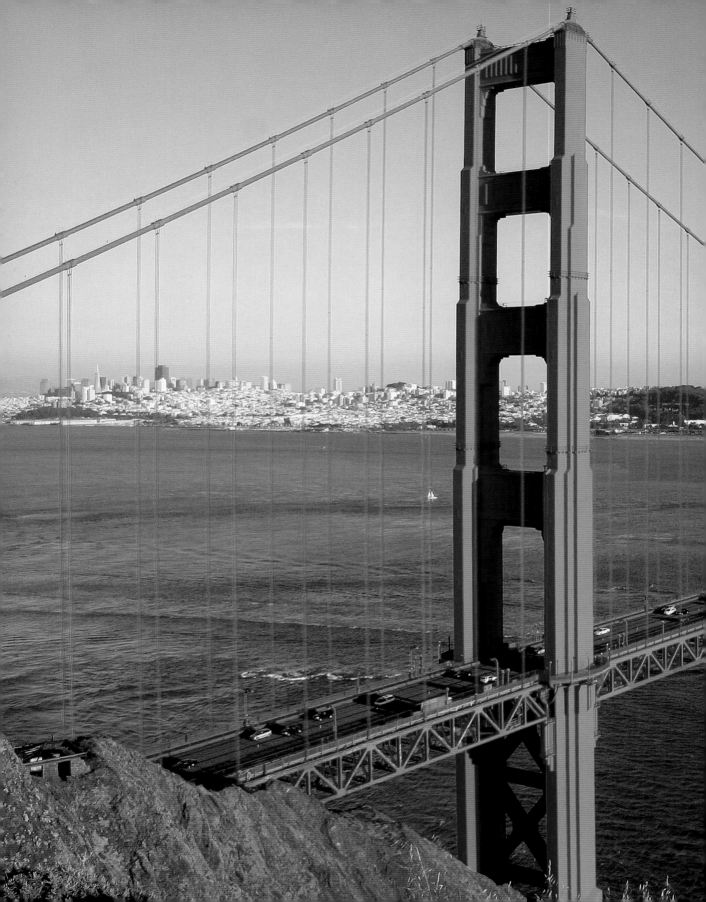

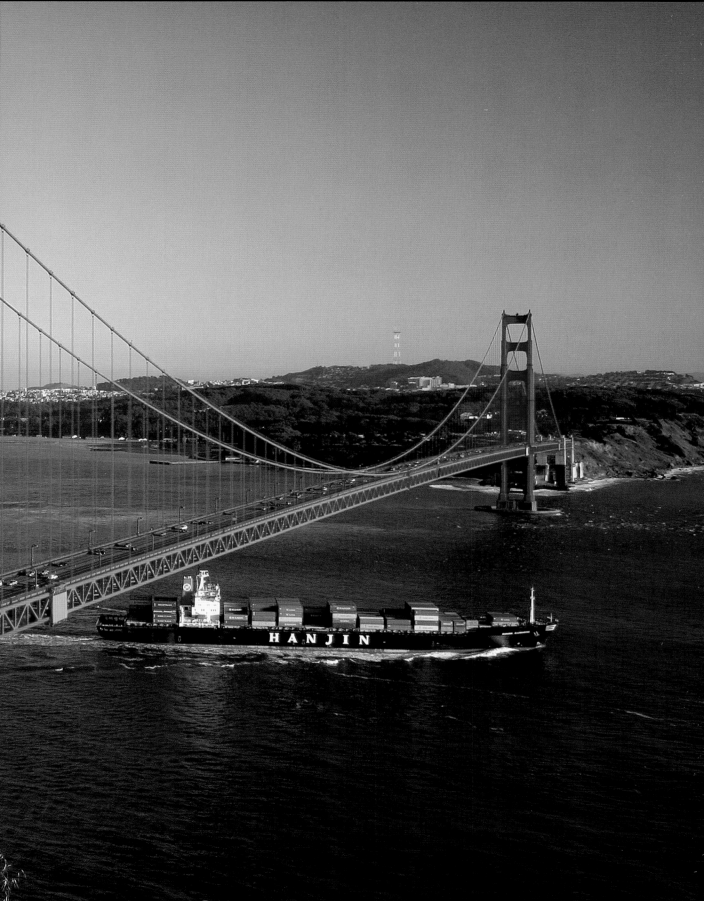

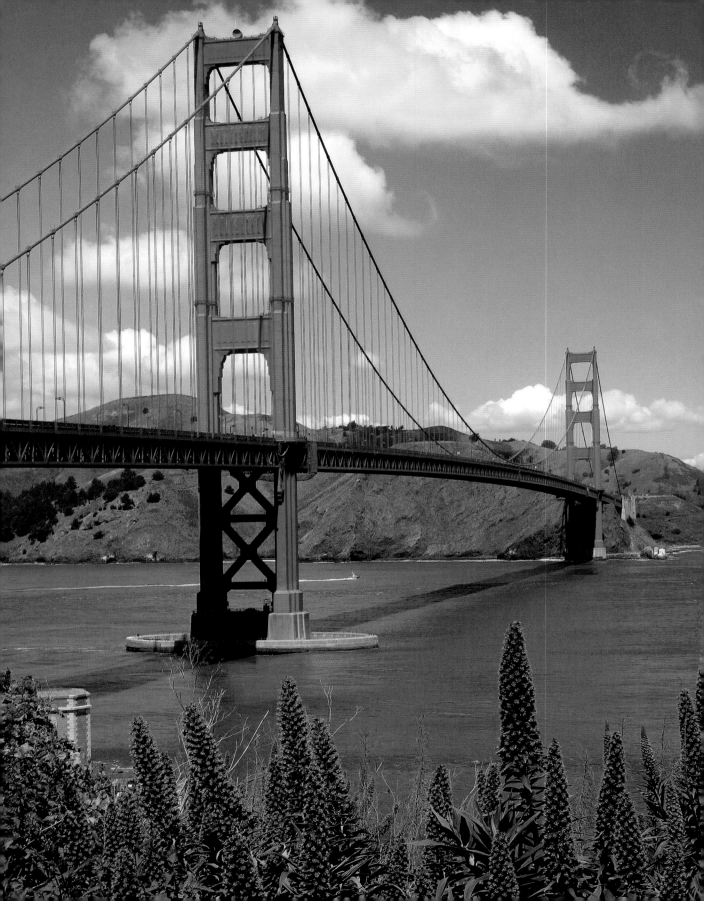

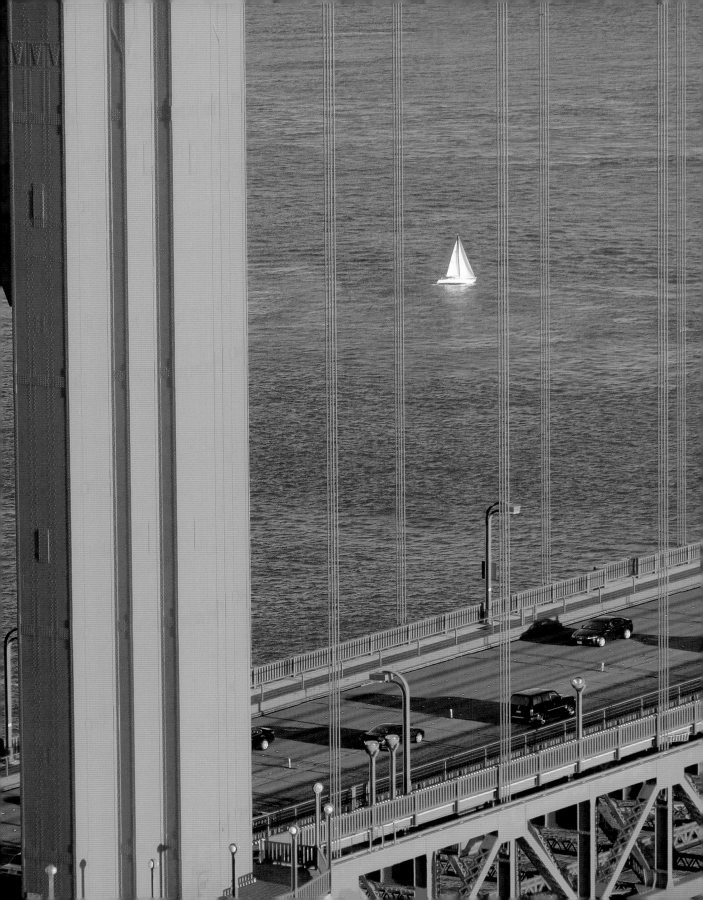

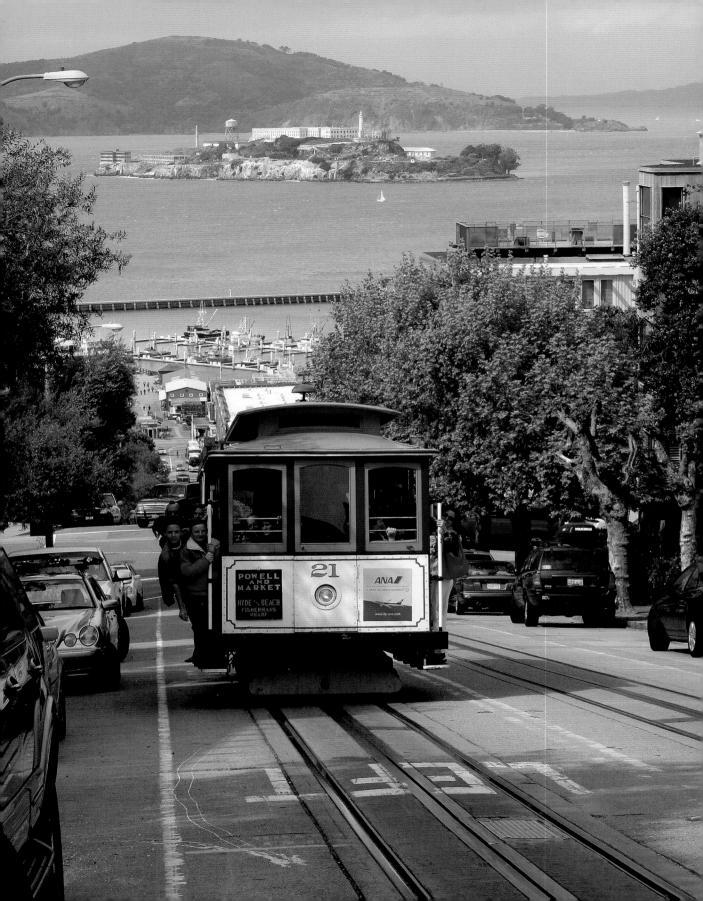

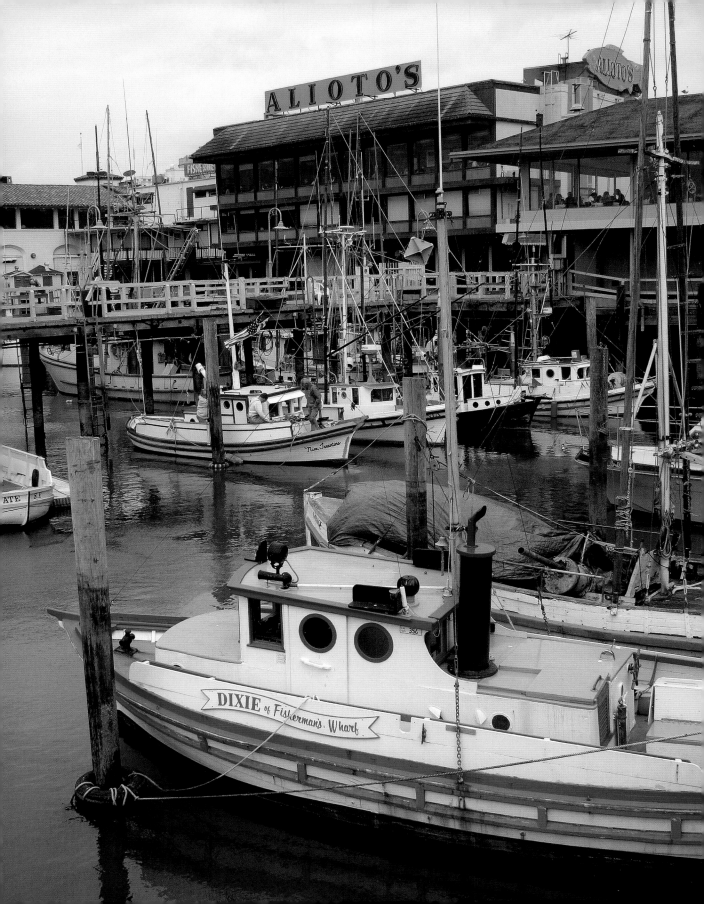

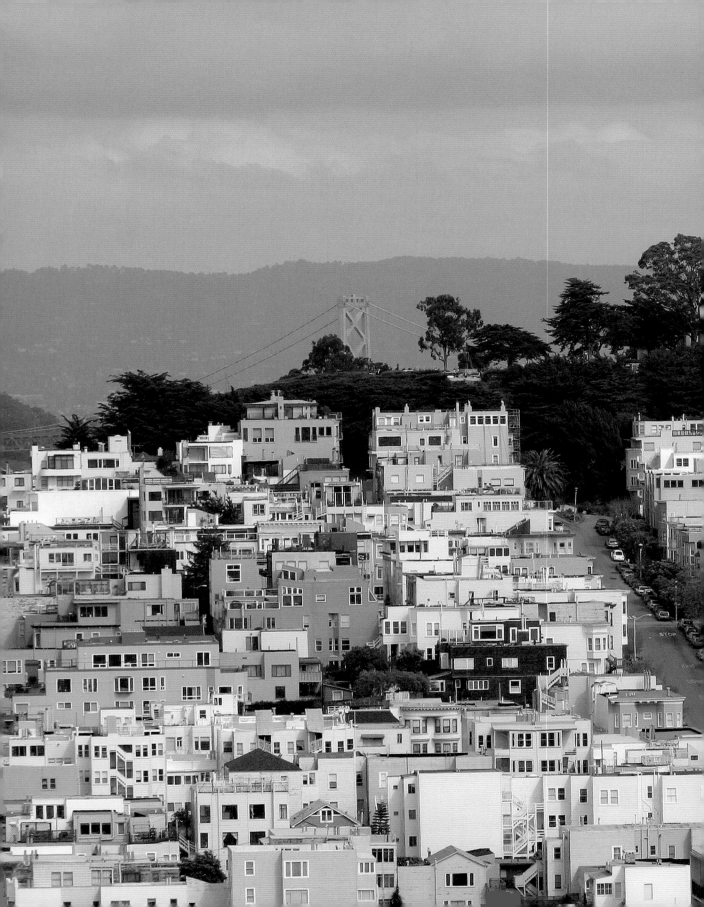

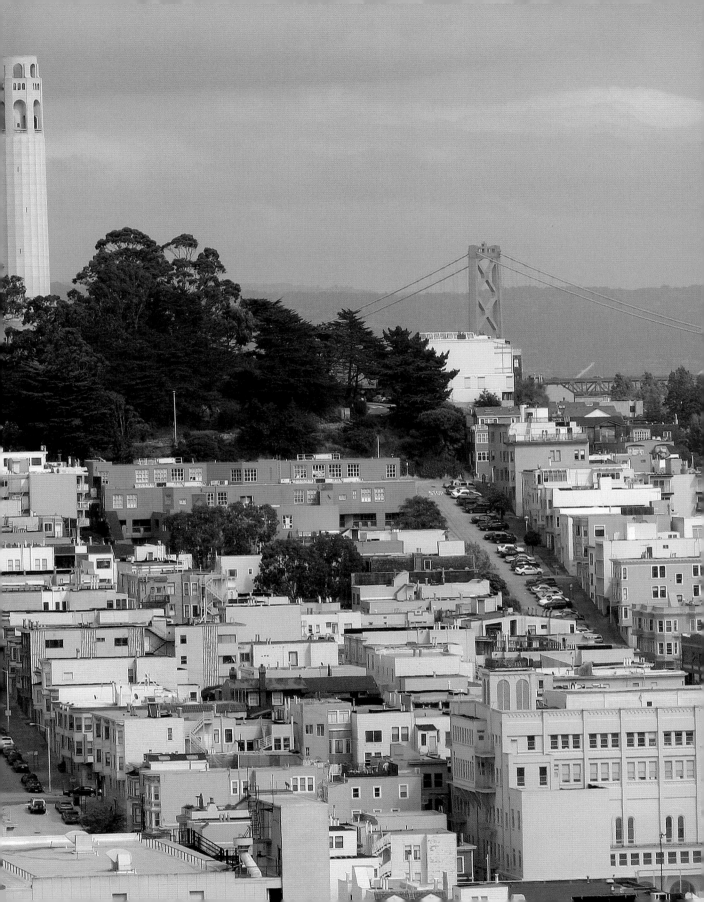

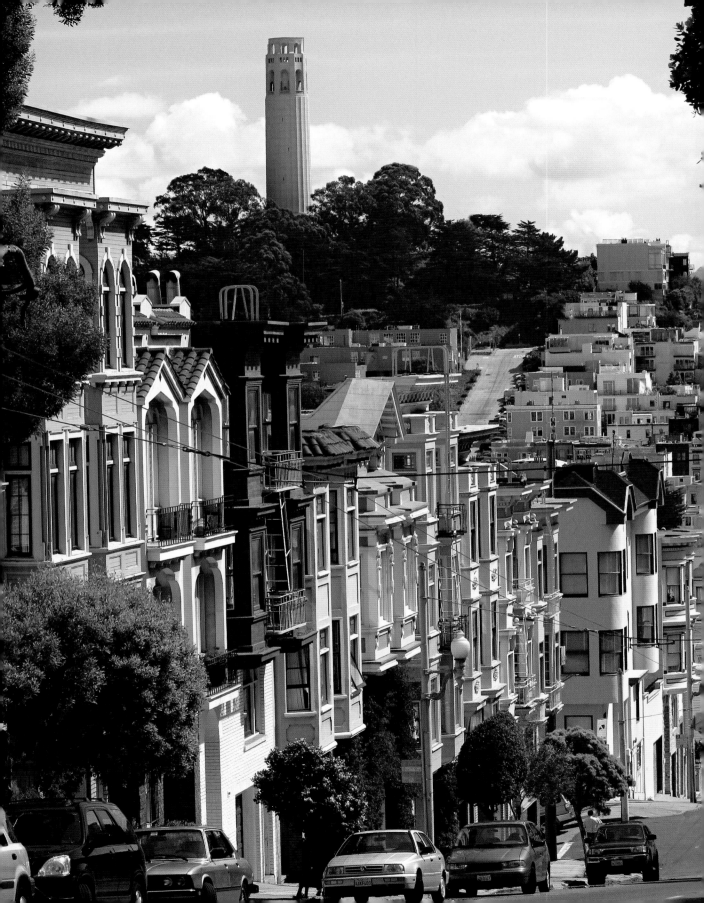

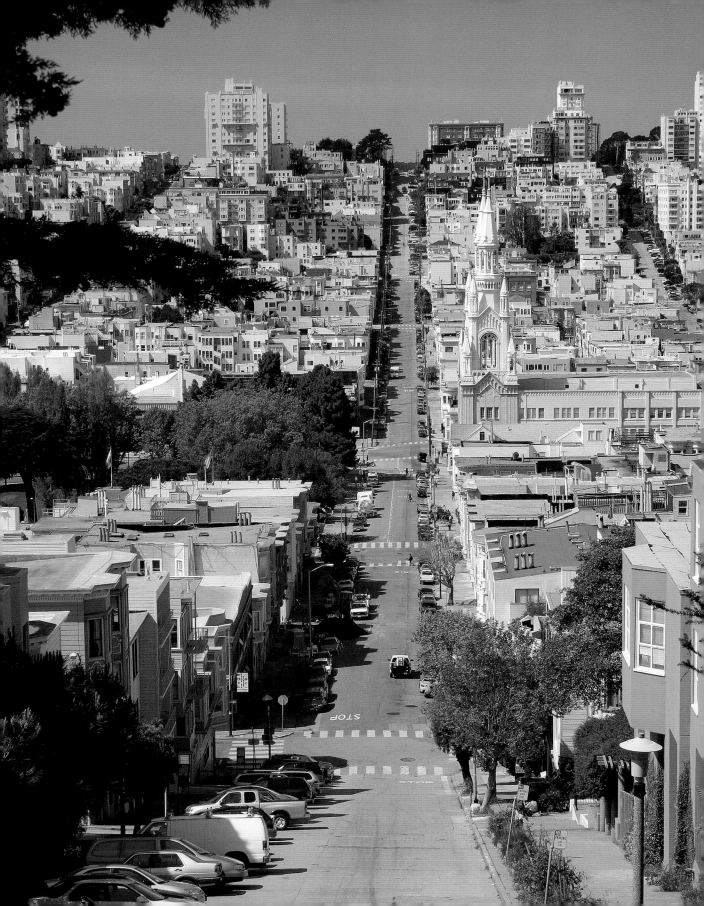

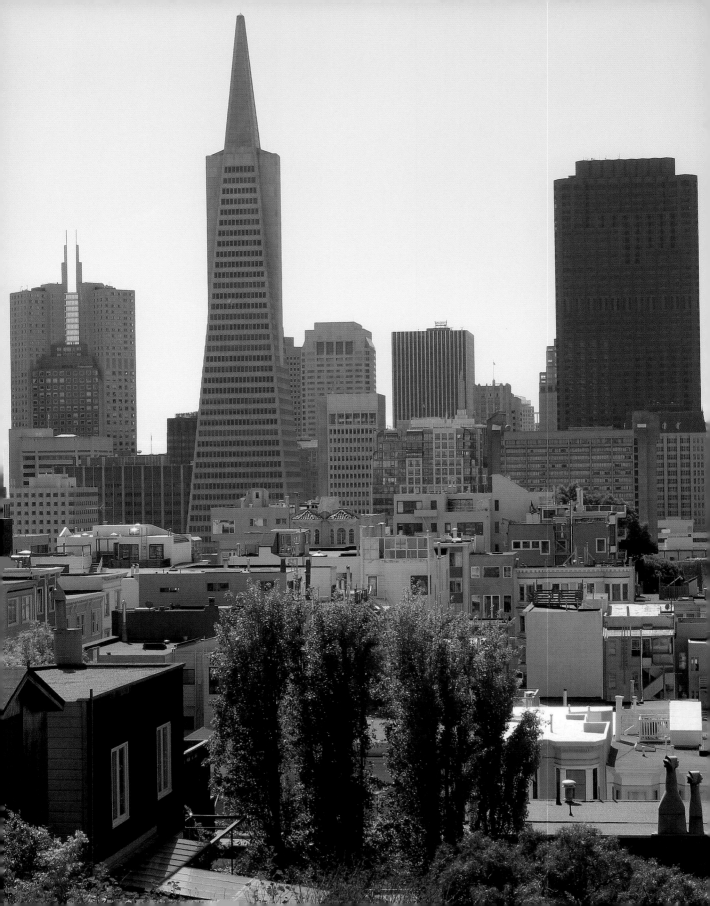

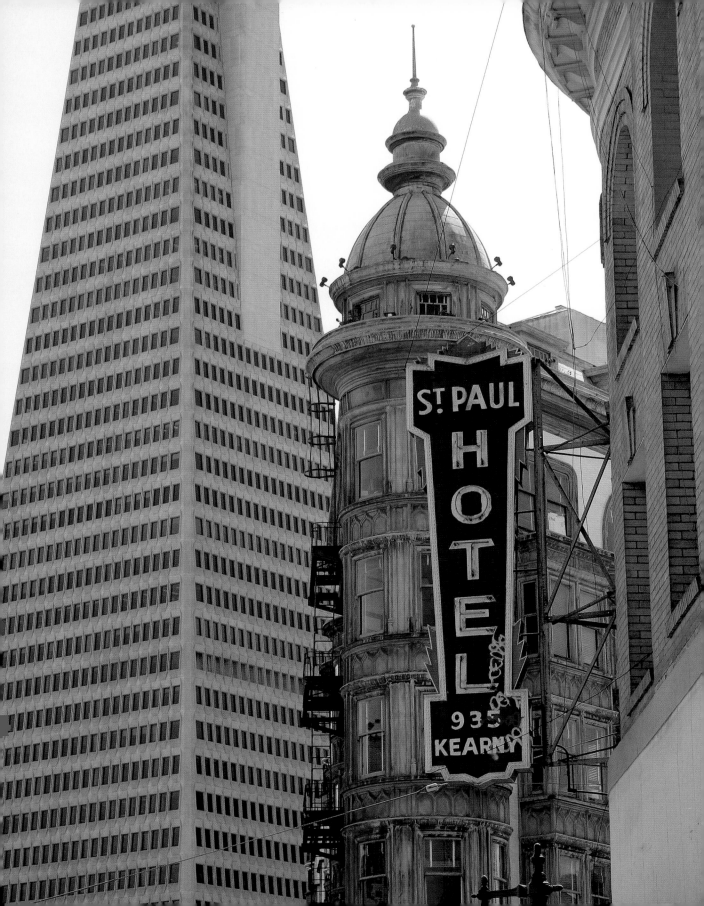

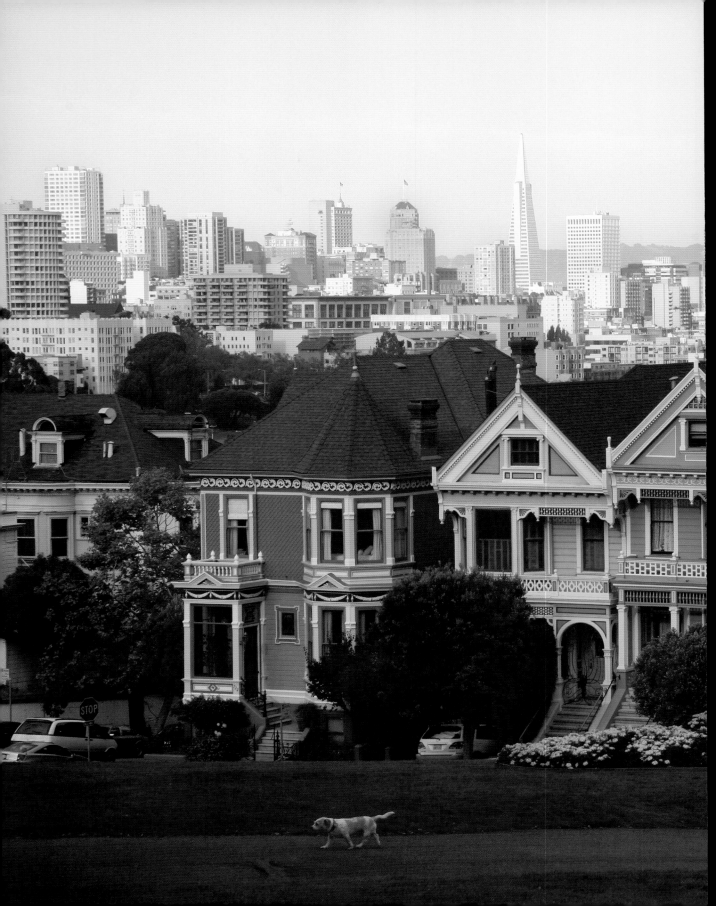

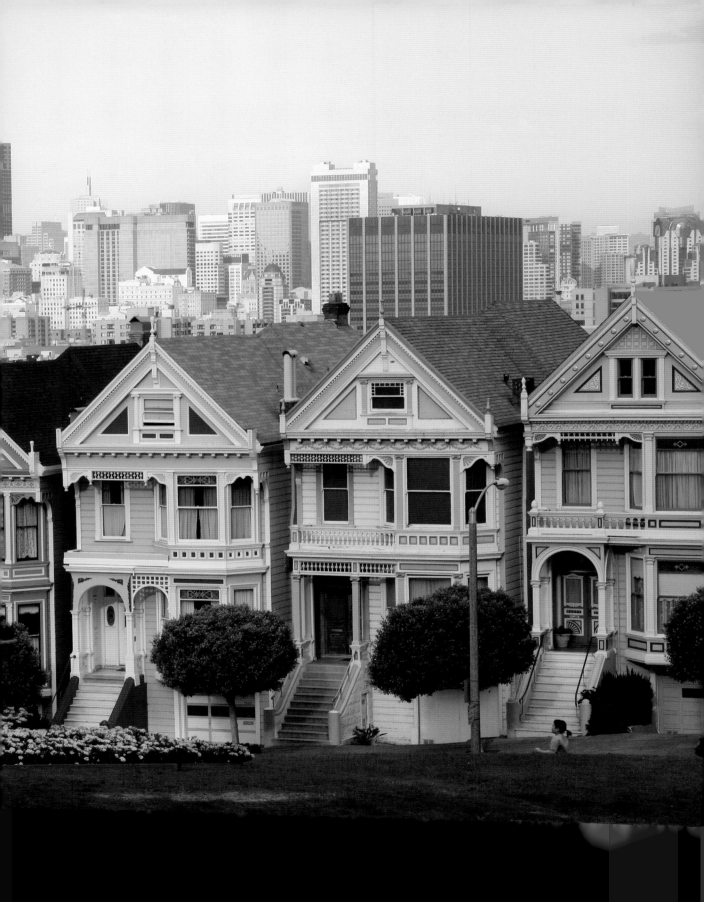

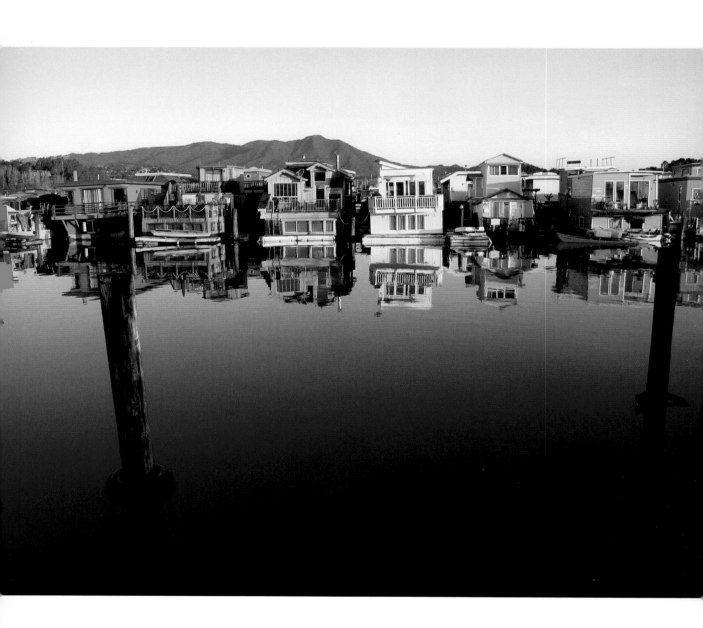

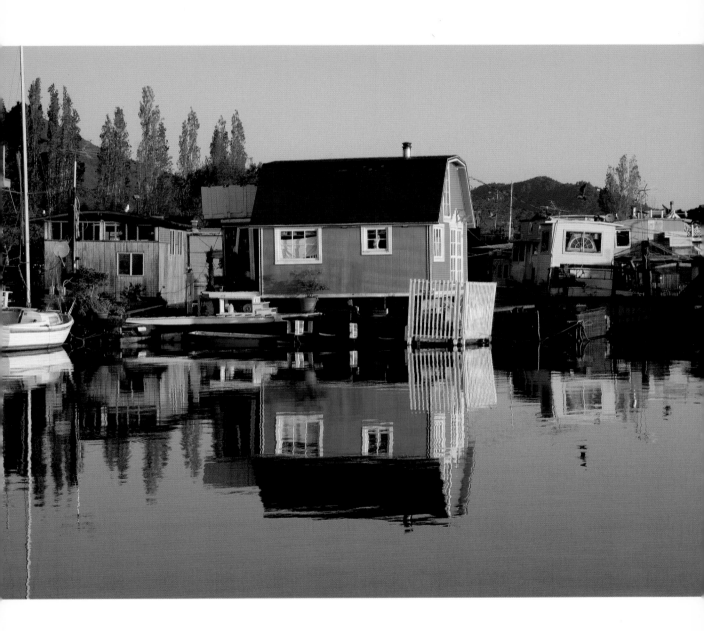

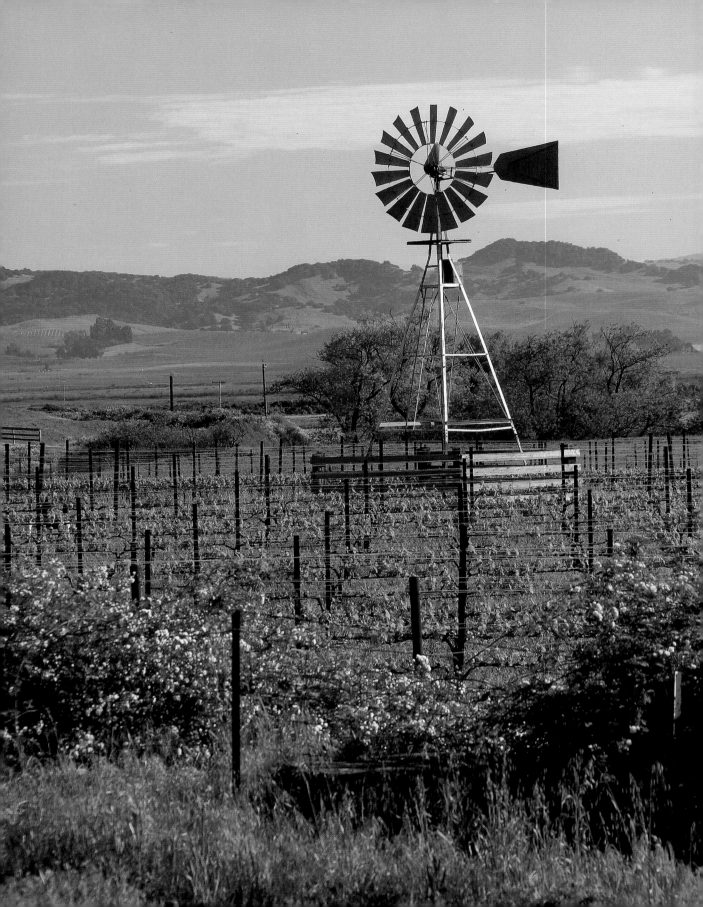

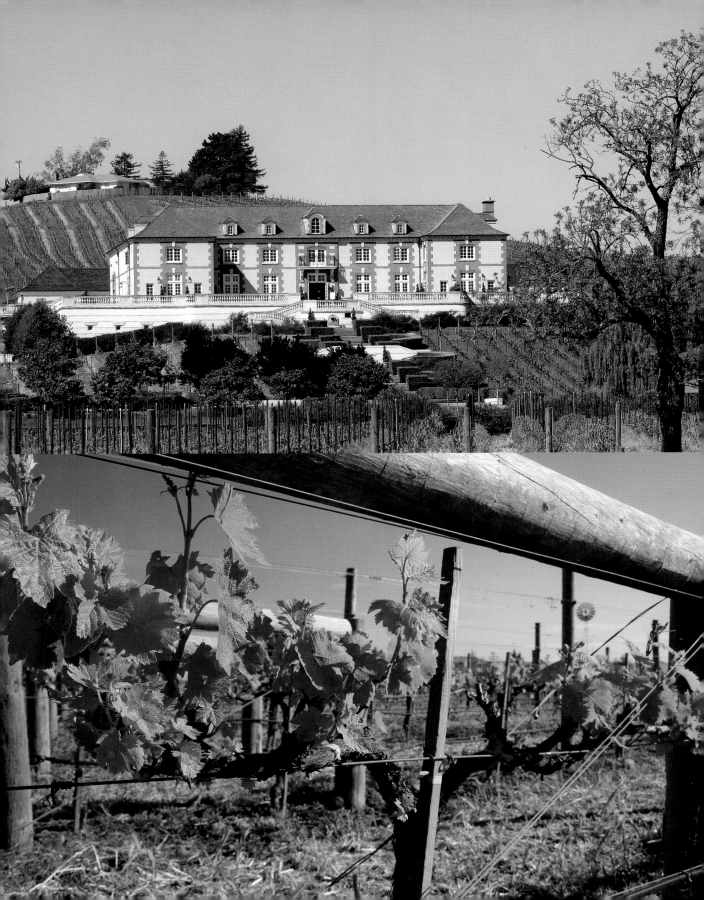

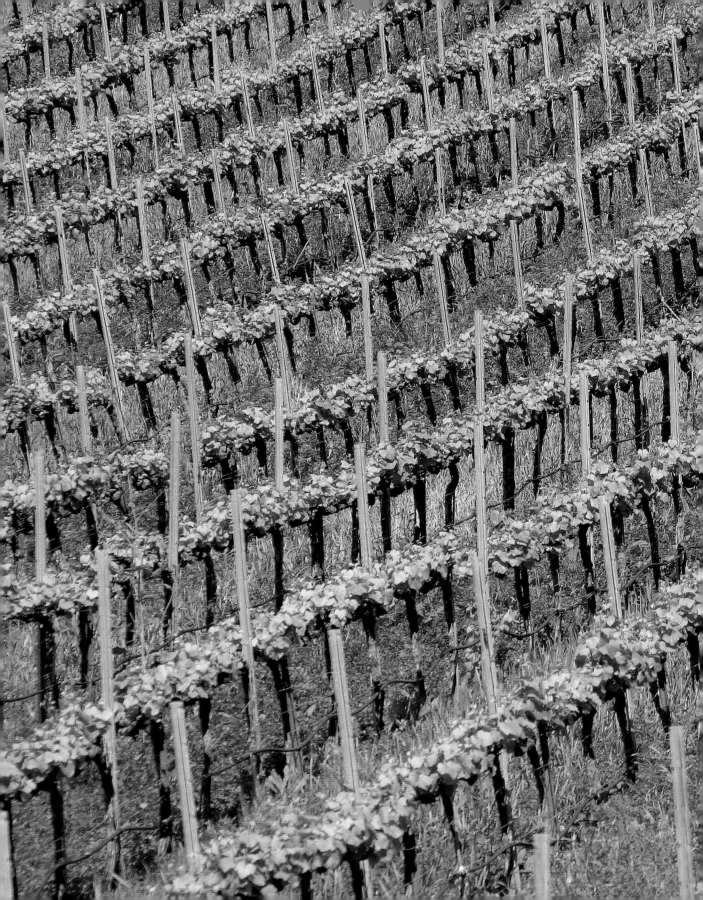

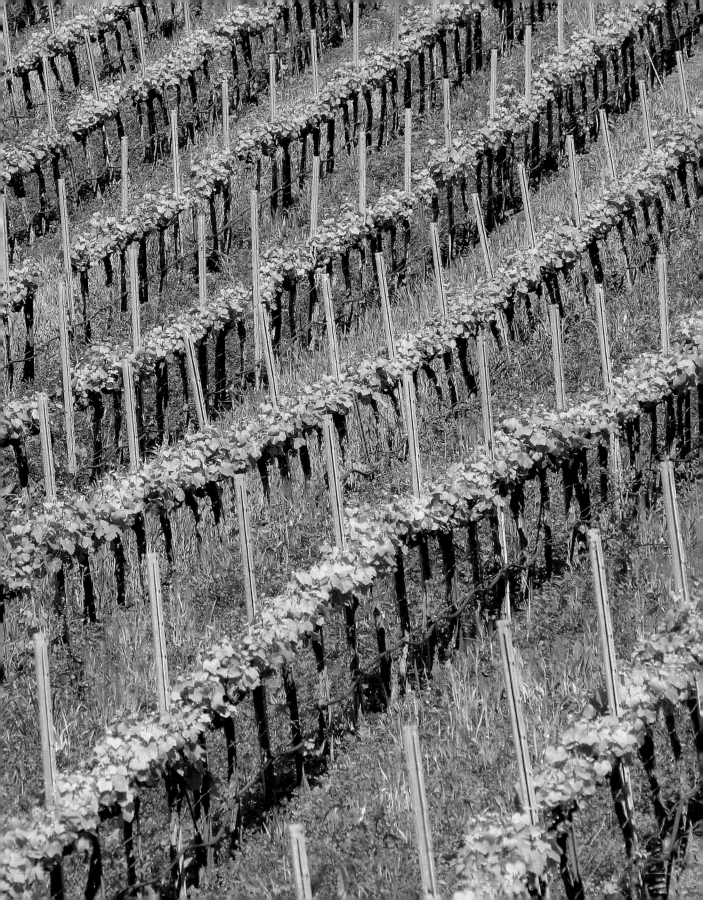

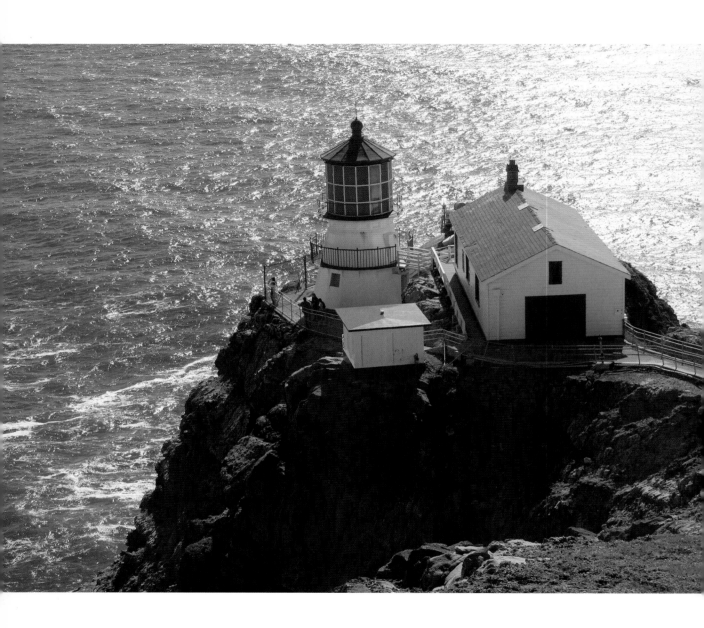

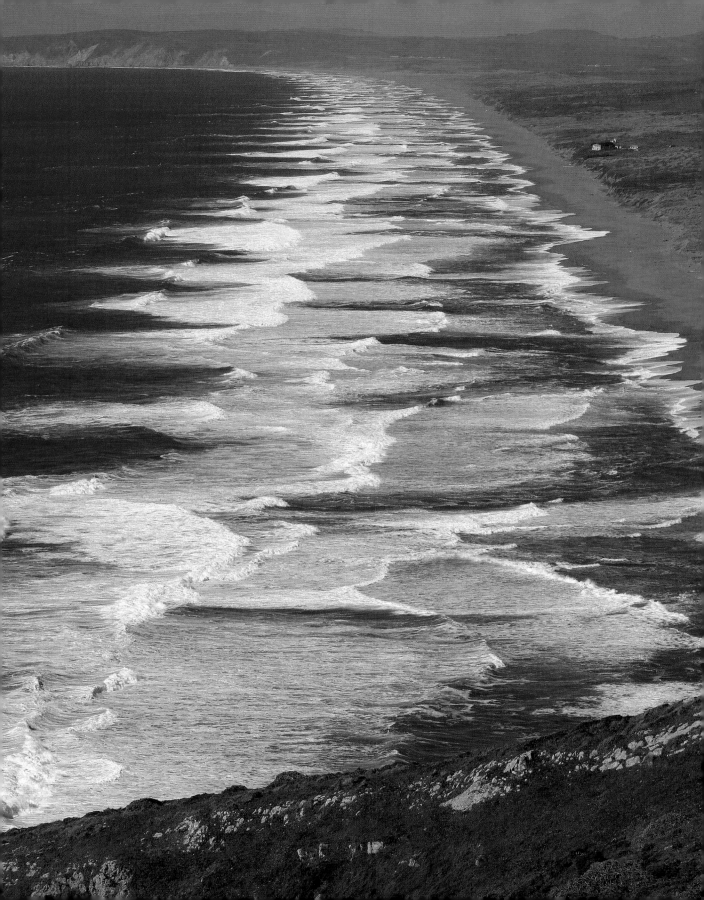

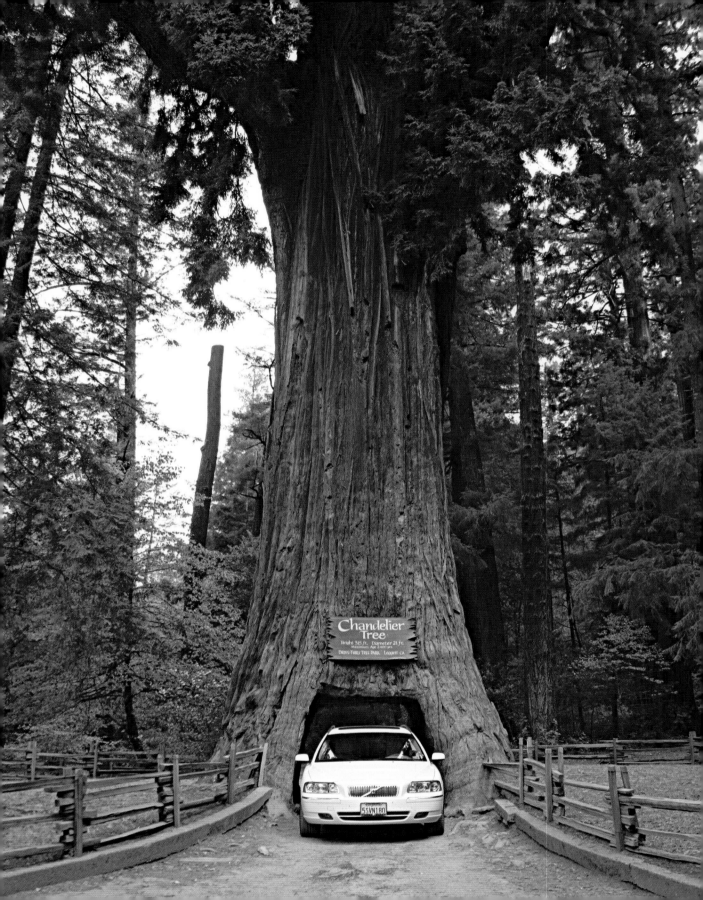

Chandelier Tree

Height 315 ft. Diameter 21 ft.
Maximum Age 2400 yrs.

DRIVE-THRU TREE PARK, Leggett, CA

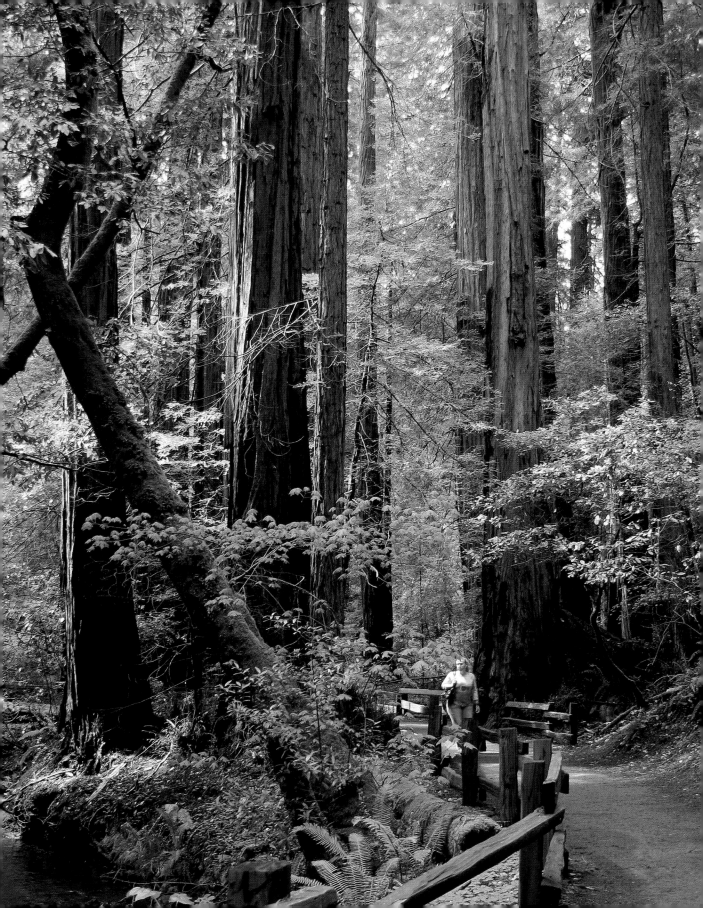

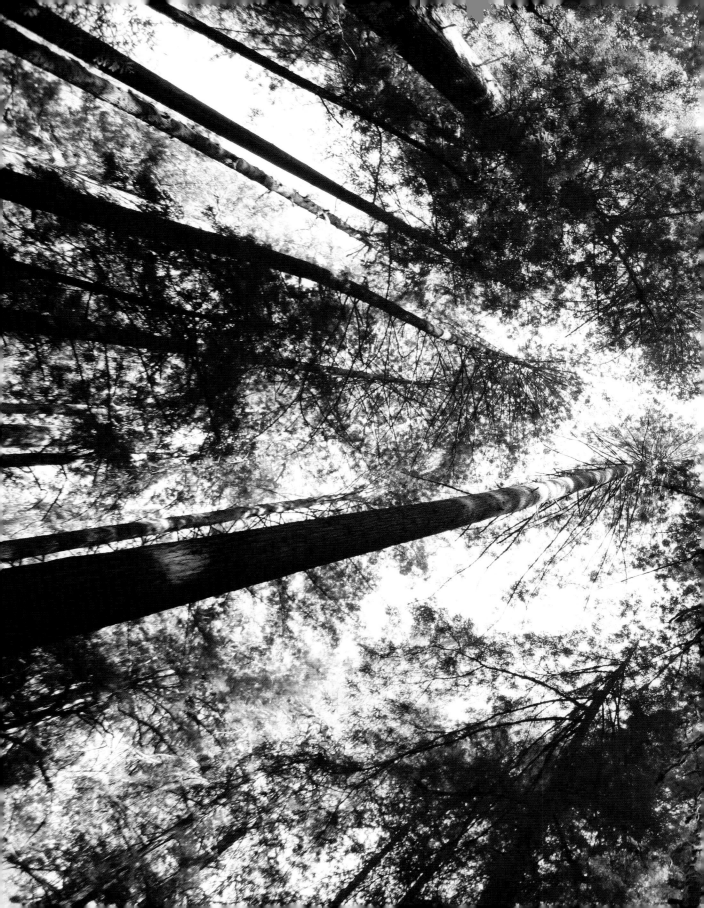

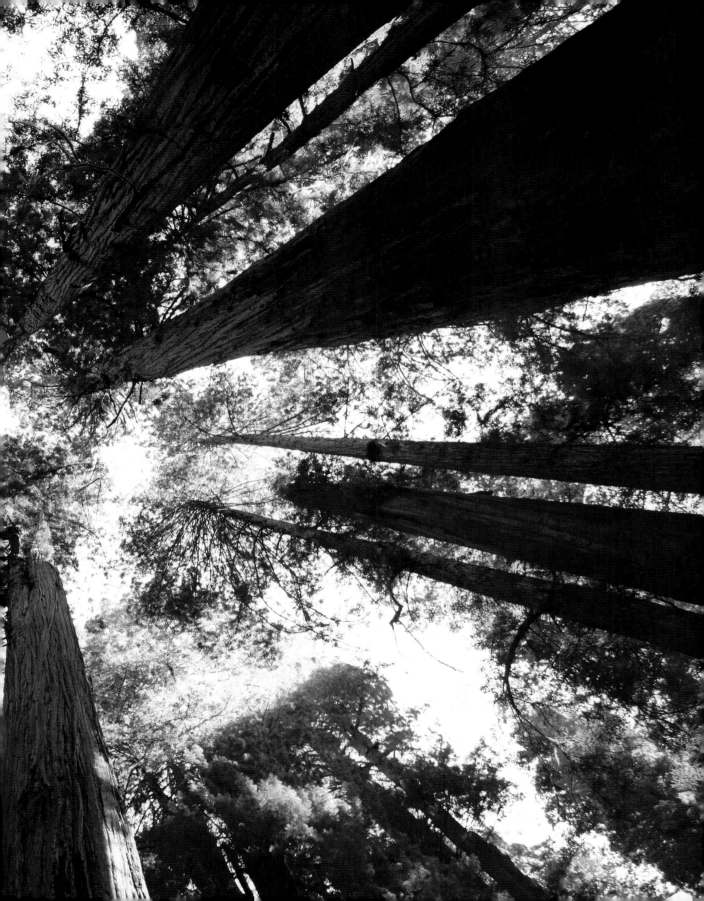

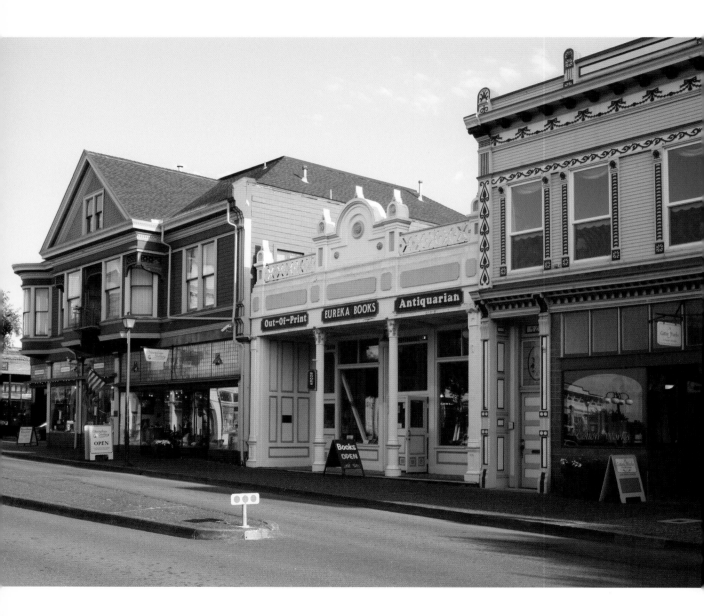

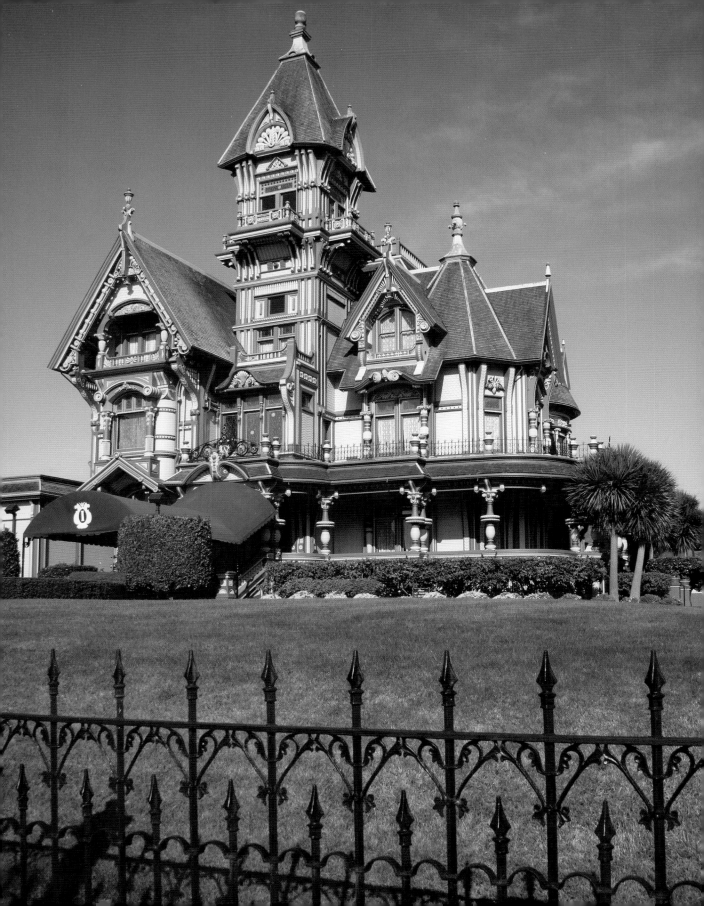

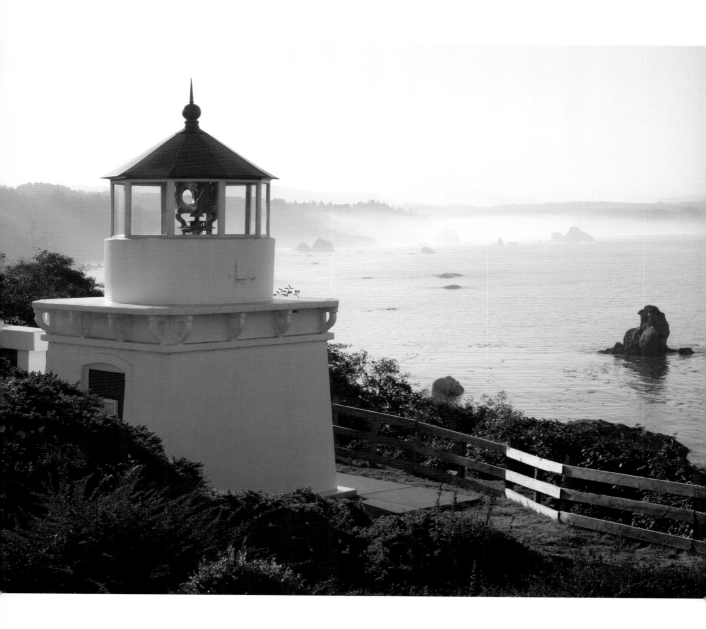

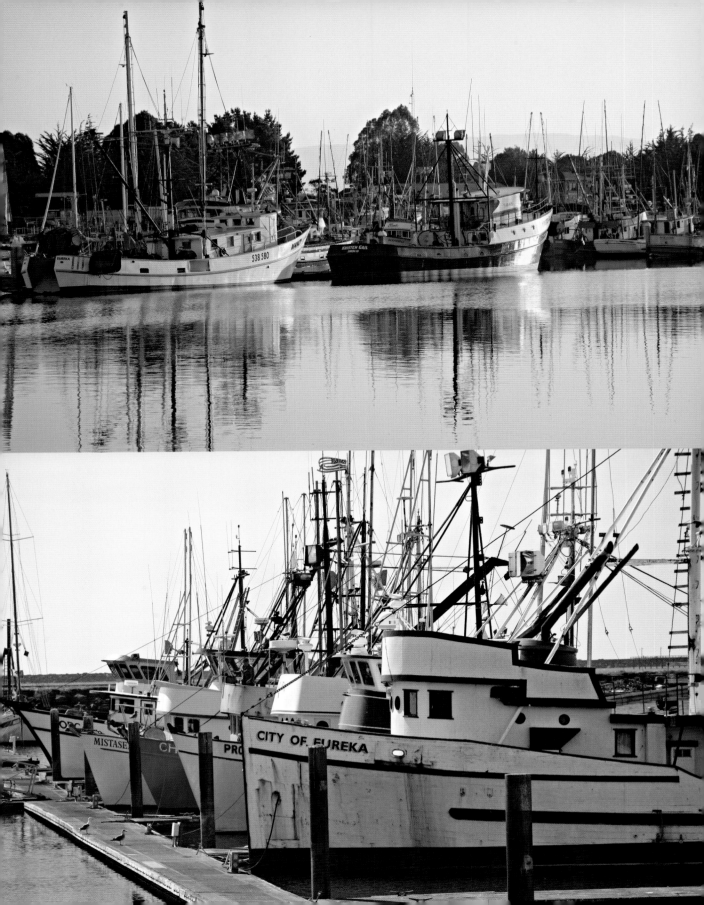

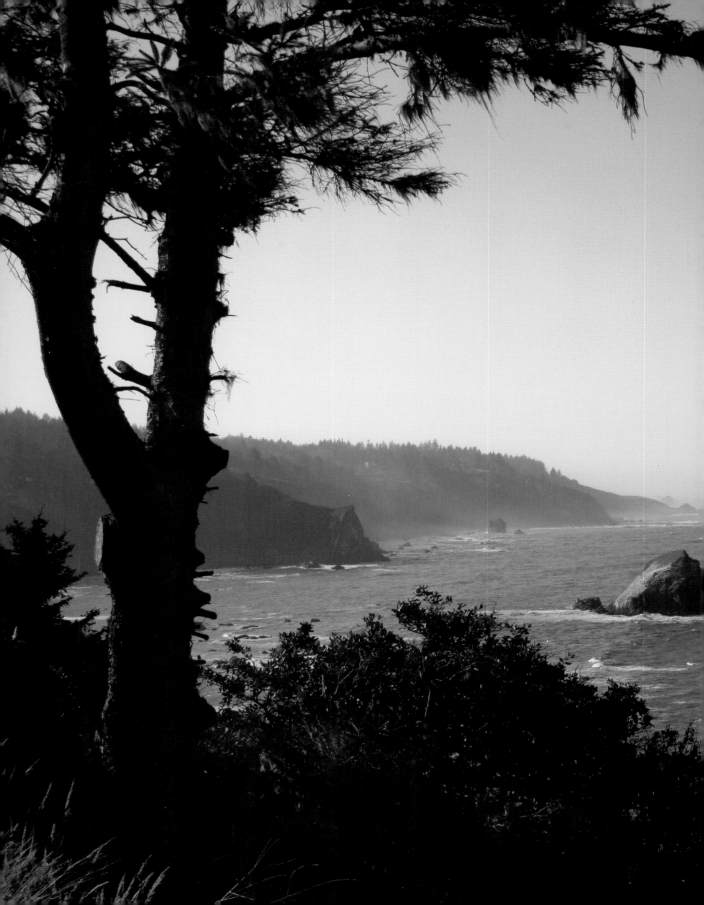

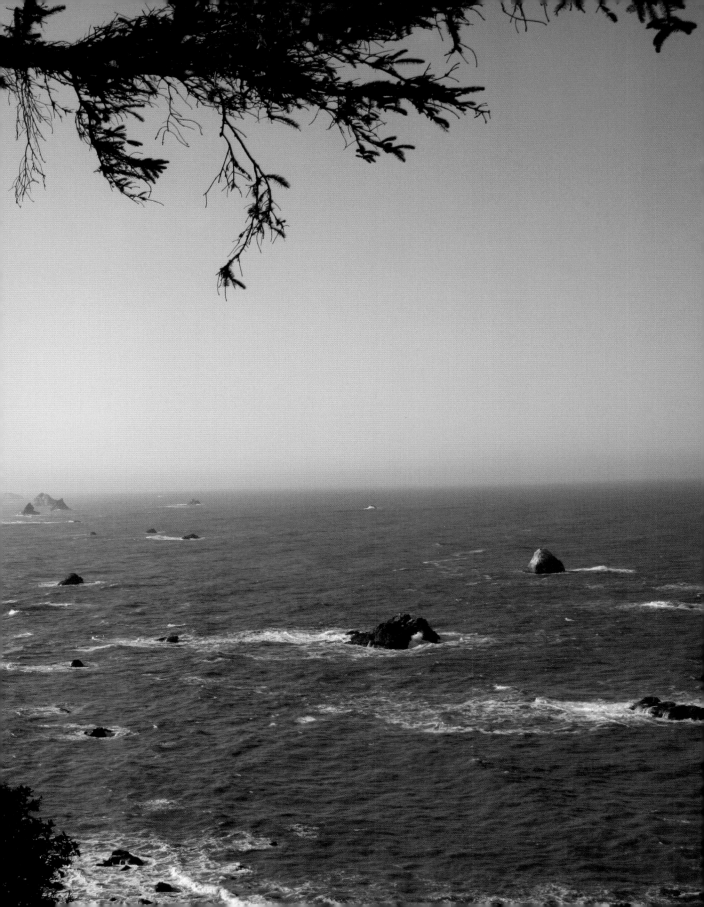

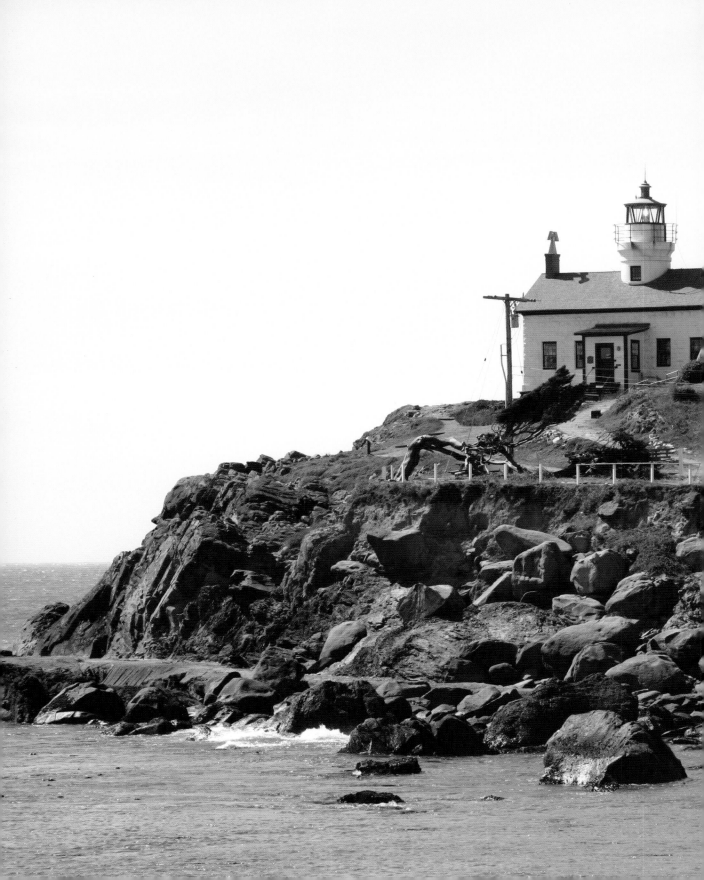

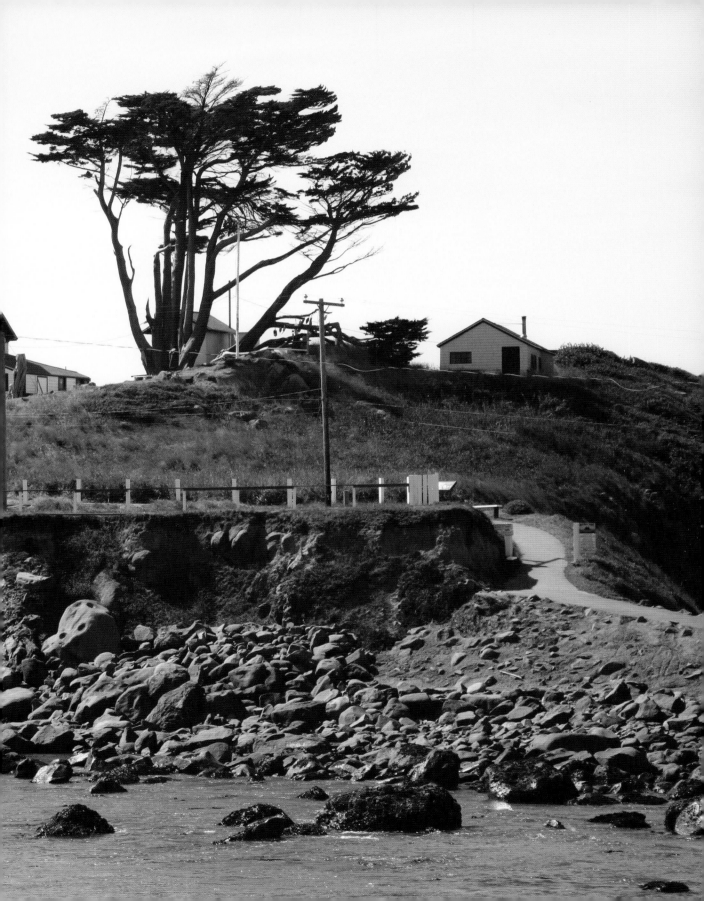

Christopher Bliss

As a native New Yorker, Christopher Bliss has always been drawn to the many facets of cosmopolitan life. He finds inspiration in urban skylines and in the challenging and invigorating lifestyles of cities. His work reflects the insight of a broad artistic sensibility.

Although always active in the field of photography, Chris began his career as a concert pianist, having studied both in Europe and the United States. Chris's work is represented by several galleries and is part of many private and corporate collections throughout the Unites States, Canada and Europe. Several of his pieces are included in the permanent collection of the Museum of the City of New York.

Christopher Bliss

Als gebürtiger New Yorker fühlte sich Christopher Bliss seit jeher zu den zahlreichen Facetten des kosmopolitischen Lebens hingezogen. Ihn inspirieren die urbanen Skylines und die unterschiedlichen Lebensstile der Großstädte, die so herausfordernd wie belebend sind. Sein Werk spiegelt eine große künstlerische Sensibilität wider.

Obgleich Chris schon immer auf dem Gebiet der Fotografie tätig war, begann er nach dem Studium in Europa und den Vereinigten Staaten seine Karriere zunächst als Konzertpianist. Chris' Arbeiten werden in mehreren Galerien ausgestellt und sind in vielen privaten und öffentlichen Sammlungen in den Vereinigten Staaten, Kanada und Europa zu finden. Einige seiner Werke wurden in die Dauerausstellung des Museum of the City of New York aufgenommen.

Christopher Bliss

Né à New York, Christopher Bliss s'est toujours senti attiré par les nombreuses facettes de la vie cosmopolite. Ce qui l'inspire, ce sont les skylines urbaines et les différents styles de vie des grandes villes qui constituent des défis et qui ont à la fois un effet stimulant. Son œuvre reflète une grande sensibilité artistique.

Bien que Chris travaille depuis longtemps dans le domaine de la photographie, il a tout d'abord commencé sa carrière en tant que pianiste concertiste après avoir suivi des études en Europe et aux Etats-Unis. Les travaux de Chris sont exposés dans plusieurs galeries et se trouvent également dans de nombreuses collections privées et publiques aux Etats-Unis, au Canada et en Europe. Quelques-unes de ses œuvres ont été intégrées à l'exposition permanente du Museum of the City of New York.

Christopher Bliss

Habiendo nacido en Nueva York, Christopher Bliss se sintió desde siempre atraído hacia las numerosas facetas de la vida cosmopolita. Le inspiran las skylines urbanas y los diferentes estilos de vida de las grandes ciudades que son tan desafiantes como estimulantes. Su obra refleja una gran sensibilidad artística.

Aunque Chris siempre había trabajado en el campo de la fotografía, inició su carrera primero como concertista de piano después de sus estudios en Europa y en los Estados Unidos. Los trabajos de Chris se exponen en varias galerías y pueden encontrarse en muchas colecciones privadas y públicas en los Estados Unidos, Canadá y Europa. Algunas de sus obras fueron acogidas en la exposición permanente del Museum of the City of New York.

Christopher Bliss

Newyorkese di nascita, Christopher Bliss è sempre stato attratto dalle numerose sfaccettature della vita cosmopolita. Egli trae ispirazione dagli skyline urbani e dai diversi stili di vita, tanto provocatori quanto stimolanti, delle grandi città. Le sue opere rispecchiano una grande sensibilità artistica.

Pur avendo sempre lavorato nel campo della fotografia, Chris ha iniziato la sua carriera come pianista da concerti, dopo aver studiato in Europa e negli Stati Uniti. I lavori di Chris vengono esposti in varie gallerie e si ritrovano in molte collezioni private e pubbliche negli Stati Uniti, in Canada e in Europa. Alcune sue opere sono entrate a fare parte della mostra permanente del Museum of the City of New York.

Directory Verzeichnis Table des matières Directorio Indice delle materie

Front cover: Big Sur, Julia Pfeiffer Burns State Park
Back cover: Golden Gate Bridge Looking North

© 2008 teNeues Verlag GmbH & Co. KG, Kempen
Photographs © 2008 Christopher Bliss
All rights reserved.
www.newyorkpictures.com

Picture and text rights reserved for all countries.
No part of this publication may be reproduced in any
manner whatsoever.
All rights reserved.

Photographs by Christopher Bliss
Design by Jenene Chesbrough
Introduction by Jean Stern
Translations by SAW Communications,
Dr. Sabine A. Werner, Mainz
Melanie Koster (German)
Céline Verschelde (French)
Silvia Gomez de Antonio (Spanish)
Elena Nobilini (Italian)
Editorial Coordination by Christina Burns, teNeues
Publishing Company

While we strive for utmost precision in every detail,
we cannot be held responsible for any inaccuracies,
neither or for any subsequent resulting loss or
damage arising.

Bibliographic information published by Die Deutsche
Bibliothek. Die Deutsche Bibliothek lists this
publication in the Deutsche Nationalbibliografie;
detailed bibliographic data is available on the Internet
at http://dnb.ddb.de.

ISBN 978-3-8327-9241-1

Printed in China

Published by teNeues Publishing Group

teNeues Verlag GmbH + Co. KG
Am Selder 37
47906 Kempen, Germany
Phone: 0049 / (0)2152 / 916 0
Fax: 0049 / (0)2152 / 916 111
Press department:
arehn@teneues.de
Phone: 0049 / (0)2152 / 916 202

teNeues Publishing Company
16 West 22nd Street
New York, N.Y. 10010, USA
Phone: 001 / 212 / 627 9090
Fax: 001 / 212 / 627 9511

teNeues Publishing UK Ltd.
P.O. Box 402
West Byfleet
KT14 7ZF, Great Britain
Phone: 0044 / (0)1932 / 40 35 09
Fax: 0044 / (0)1932 / 40 35 14

teNeues France S.A.R.L.
93, rue Bannier
45000 Orléans, France
Phone: 0033 / (0)2 / 38 54 10 71
Fax: 0033 / (0)2 / 38 62 53 40

www.teneues.com

teNeues Publishing Group
Kempen
Düsseldorf
Hamburg
London
Madrid
Milan
Munich
New York
Paris

teNeues

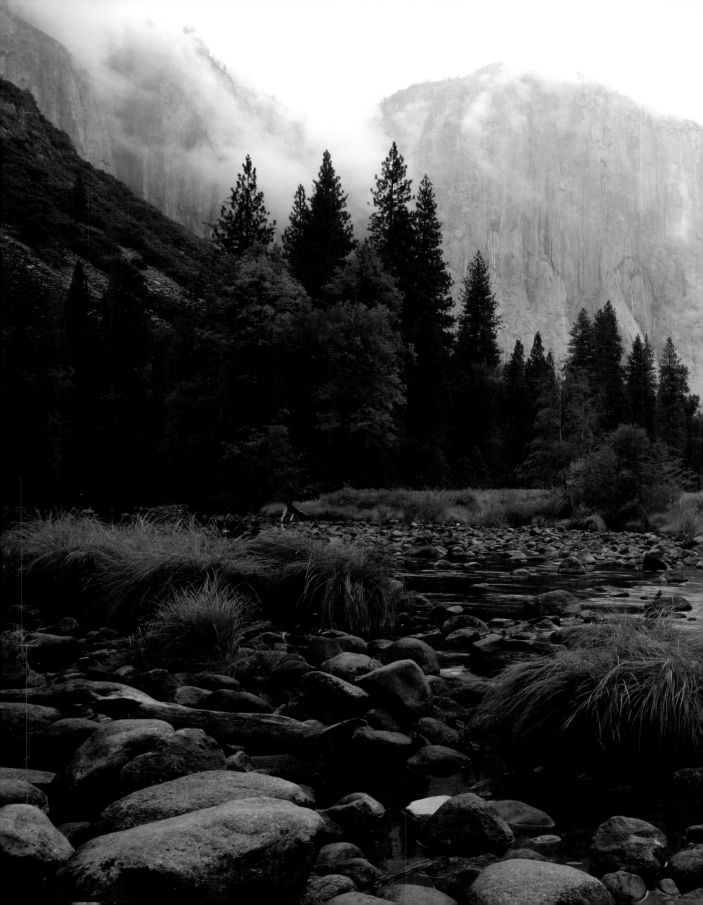